BOOK THE JOB! (FOR TEENS)

A Guide for Actors

Anthony Meindl

ISBN: 1543241557
ISBN 13: 9781543241556

Acknowledgements

How do I acknowledge so many? It seems impossible. For every interaction with an actor I've ever had through all the years — you have enriched my life and forged this teaching. Surely, we are all part of a collaborative art form, but teachers too often work from a supposition that they have knowledge to impart on the pupil. Indeed, that may be true (that's why we're teachers), but the deeper insight is that teaching actually comes *from the student.* Each person individually shows us what he or she needs through their fears and hopes and desires and blocks. It's an interactive relationship that, when entered consciously, truly takes all participants to a higher level. I never knew I would learn so much from you all.

For that I am grateful.

To take this book from the world of imagination to the thing you're holding in your hands right now, there are a few people I'd like to thank specifically.

To my editor, Sharon, for taking out the carving knife and not being scared to fricassee me (and my words) at every turn. You are challenging, maddening, and insightfully patient and smart.

To the AMAW office staff — Robin, Tyler, Eric, Barbara, Candice, Shelley, Diva, and Sam — I am most impressed by all the things I *don't know happen* (including Friday Drink Days!), because you're so good at putting out the fires and making things in front of the curtain seem like a beautiful magic show! Thanks for the innumerable things you do that I don't always have the chance to thank you for doing.

To the AMAW teachers *all over the world*! When did this happen? Thank you for being emissaries of light and joy and truth and passion. Thank you for coming into my life and taking on the mantle of teacher, in addition to all the other wonderful things you do. To be real in a world that is mostly *un*real is the hardest thing to be, and you all show actors everyday how to be this more bravely. Bravo.

Is it weird to thank the art form itself? Well I don't care. I'm going to. This thing we call acting — what an amazing, weird, wild, wonderful ride it is. To make art out of ourselves. To make art out of our pain and suffering; our joys and victories; our fears and funkiness. I've been in the business my entire adult life. I know nothing other than this expression. I'm not sure how the rest of the world works, but to do what we do — to seek something that is so ineffable and almost always a hair's breadth away from us, and try to find some way to express that through storytelling — that is the mystery of being alive itself. My God! It's amazing. Who would we be without this art? I'm not sure civilization could exist. So, thank you.

And the Divine, specifically expressed through the vehicle of my guru, Paramahansa Yogananda. Even though I stray. Even though I rail against the universe; scream, yell, throw things, act like a 4-year-old brat. Even though I often want to scratch and claw my way out of my experience of spirit and just go back to being Neanderthal, I always seem to find my way back to you. Or rather, I just go back to where I started. I've learned through all things that it's okay to have contrary thoughts about you, to question, to probe, to doubt, to keep asking, "Why?" And in so doing, I am lead back to the same answer. It's not anywhere but in Self. It's not only enough, it's also everything. Thank you for teaching me that life is about holding on for dear life (!) while simultaneously letting go completely.

Table of Contents

The Heart

The Industry

Introduction

Book the job!

"How do I do that?" you might ask.

The answer is simple. It's what everyone, everywhere, throughout hundreds of years in all walks of life and all vocations — from the greatest spiritual teachers to probably your mom and dad — have told you.

Be yourself.

And there's the rub. That may be the hardest thing you'll ever have to *be* in this life.

Period.

From our earliest age, we identify with images projected onto us *by other people* of what success, fame, happiness, beauty, worthiness, love, and pretty much everything else that we construct in our still-developing brains tells us we should be.

From the inside looking out, we don't see ourselves as beautiful or powerful or talented or amazing. Why? Because our image of self can never measure up to the false images that are absorbed by our internal software. So, we conclude, we must

be messed up, flawed, stupid, ugly, undesirable, incapable, and incompetent.

And we spend our lives trying as hard as we can to compensate for our perceived lack. If we're stronger, smarter, taller, buffer, prettier, funnier, darker, lighter, thinner, younger, older, wealthier, cleverer — we'd be somebody. If a teacher, guru, lover, sibling, parent, director, producer, casting director, boss, or friend would give us the answer — we would be it.

That false assumption right there puts us immediately on wrong footing in our own lives, and it also creates the seed of "acting" that turns everything to crap. So the real work in our lives — and if we're actors, in our actual work — is to undo all the "doing" that we've been taught we need in order to *be*.

Most typical acting books try to ascribe a fixed way or "technique" to something that is unfixed and too varied to begin with. Acting's not a recipe. Two tablespoons of this and a quart of that = a perfect muffin. I always struggled with applying something rote to an experience that never followed 1 + 1 = 2. A life in the arts isn't linear. It doesn't mathematically equate that way.

Because "acting" problems are almost always *life* problems. Or perhaps a better way to say it is "life challenges", which are much more complex and scary and weird, and ultimately, what every person on the planet is going through, every day. Everyone deals with the love, pain, desire, compassion,

empathy, fear, hope, anger, rage, joy, and wonder of being alive. And eventually, facing our own demise. The mystery is in all these moments in each of us — and of course in our art. In our acting.

Makes sense, doesn't it?

But we still need practical tools to build technique (i.e., an emotional understanding) of the work that then becomes the *process* in how actors can stop "acting" and just tell stories — with conflict, intimacy, ambition, power, desire, and vulnerability — just like we are living (and telling) simply by being here.

We've heard these things before: "Stop trying so hard." "You don't have to push." "Allow yourself to be." "Trust." "Let go of control." "Stop showing." "Breathe."

How do we do these things — and ultimately book a job — if our own internal wiring is hooked up to the false beliefs that we have to be "someone else" in order to succeed?

This book will show you how.

The process for this book began by collecting the most frequently asked — as well as some of the more complex and multi-faceted — questions from our students over the years. From technical and terminology questions to business questions to booking jobs to allowing yourself to feel, and

ultimately to remembering why the hell you wanted to do this in the first place! — we're going to examine all of it.

The technical aspects of acting aren't hard to grasp. (Even though for *years* we've been taught that they are and it totally messes with our heads!) What is hard, though, is what's hard for each of us in life: getting out of our own way, realizing we deserve so much more than we give ourselves credit for, eliminating the saboteur within, feeling free while taking huge risks, allowing ourselves to be vulnerable, sharing our passion, learning how to stop editing and censoring ourselves, and being brave enough to fail (and therefore, ultimately, succeed).

In the end, all the answers come back to that original truth: Be yourself.

In so doing, you'll see that most of the things we've spent trying to find the answers in — a lover, a job, a city, a vacation, a teacher, a guru, a church, a philosophy, a parent — are already inside you.

So you have a question?

But you also hold the answer.

And that, then, is how you're going to book the job.

The truth is you can do it.

Let me say it again: You. Can. Do. This.

How?

By being yourself.

The Head

1. How do I develop "technique"?

The late, great, 4-time Tony Award nominee, Elaine Stritch, says, "These performers that go on about their technique and craft — oh, puhleeze! How boring! I don't know what 'technique' means. But I do know what experience is."[1]

Watching sad movies can give you technique. Volunteering at a soup kitchen or a children's hospital. Realizing that in many places in the world, life involves surviving mass genocide or war. Or living on $1.50 a day.

Anything that makes you emotionally available and fully present with those feelings and then *sharing them* is technique. Staying open when you want to shut down is technique. *Experiencing* your life is technique.

End. Of. Story.

So how do we get to the experience of something that thereby creates "technique" in our work?

Acting has two parts:

1) Text. (aka story)

2) Feeling. (One could argue it's also about behavior and physicality and our bodies and voice and breath, but feeling is supported by — and comes out of — our

3

physical being, so I'm using the broad term "feeling" here to understand our entire psycho-emotional, physical, and vocal self.)

Text without feeling is just saying lines. *Ain't nobody got time for that!* If I wanted lines with absolutely no empathy, compassion, or love, I'd just call up my ex-boyfriend. *BAM!*

Feeling without story is just a lot of random emoting. *Ain't nobody got time for that either!* I'll just watch my favorite telenovela with the sound turned down. Or go watch an acting class where there's a lot of writhing around on the floor, exorcising our demons, and getting in touch with our emotional birth canal.

Been there. Done that. And am still not sure what *any* of that has to do with feeling or telling story. Except it made me feel icky and weird; self-conscious and indulgent. So feeling *itself* is also not the answer.

The goal of acting — and the fulfillment of technique — is the ability to use our feelings in a way to tell story without the feeling part getting in the storytelling way. Or as Academy Award winner Marion Cotillard says, "I don't think you learn how to act. You learn how to use your emotions and feelings."[2]

And we do that by feeling and expressing more deep and unfamiliar feeling all the time. And while developing ourselves

— stop telling ourselves we can't feel certain things. In our acting and life. Just feel it all and see where it goes.

Teachers say, "Well, the character wouldn't feel that there because that goes against his need." That's a non-answer and actually runs counter to the truth of life. We do (and feel!) and express things that contradict our needs *all* the time (more on that later).

Allowing ourselves to truly feel can be hard and this is why we call it technique. I've often had actors at our studios say that what is being asked of them in class is harder than what they allow themselves to feel in their own lives. That's because in life, we can get away with *not* feeling, or we come up with clever ways to disguise what we're feeling as a default, rationalization, or excuse.

But telling story through narratives often asks us to confront all feeling head-on. By building our emotional facility so that we can feel feeling freely is the goal and it's also the by-product of developing emotionally.

Some people do this by being in acting classes. Other actors do this by having been on tons of movie sets at an early age and developing emotional availability that way. Others do it by giving themselves the permission to have the experiences *their* way in life and bring that to what they do.

It doesn't really matter where you get it.

Of course, I advocate taking acting classes because it's a direct line to getting people to discover who they are and express themselves through storytelling in cathartic, healing, and empowering ways in an emotionally safe space. But some people have amazing technique without ever having taken a class. That doesn't make them less of an actor. It shows that our understanding of technique is misinformed. And demonstrates that the real meaning of technique is for each of us to be as honest and emotionally available to *ourselves* as we can be, and when we do that through playing a role, we experience how technique supports us.

We, each of us, become our own technique.

Our hearts, our souls, our pain, our victories, our heartbeats, our love, our passion is what sustains and supports us. That's the real definition of "technique" and truly, all we're ever going to have.

2. What is a "beat"?

Stanislavski (I'm assuming we all know who he is?) originally came up with the term "beat", which basically is used to delineate in a script a change of tactic in pursuing a longer action that an actor is going for in a scene. Sometimes it's defined as the smallest unit of action that has a beginning, middle, and end. A unit would be a portion of a scene that contains one objective for the actor. So the beat, or unit, would change every time a shift occurred in a scene.

Still following me? Because I need a margarita!

So the actor breaks the script down and marks where the beats are and where the corresponding objectives occur within each unit of the scene, and then attributes a physical action to each objective to pursue something on each line (playing a verb).

Grrrrr . . . Please make that a double!

How often do we do that in life? *Never.* There's got to be an easier way!

There is.

First off. Understand the script. Know what's going on, what the scene's about. You can also even loosely trace where beats are in the material — which *aren't hard to find* because different beats basically suggest a change of focus. This can be in

the form of new information, a change in tempo or intensity, a discovery, an "A-ha" moment. All of this can be understood by simply reading the scene, because every scene is going to ostensibly have many changes since new information is going to be occurring in *every* moment.

The departure here from perhaps a traditional approach is that instead of playing your breakdown of the scene with your instructed beats — and how you want to say the lines — you instead let the listening do the work for you. Listening will automatically create "beats" for you. And it will do so with greater frequency and greater insight than marking your page.

I'm not suggesting that you ignore when a beat occurs. And I'm not saying that you won't have ideas about how you might want to play them. I'm not even saying it's bad sometimes to mark on your script a specific line that you know probably should be delivered a certain way. You may get a note from the casting director that a certain section is supposed to be one way or another, or the director on set wants it said *exactly* as she told you to say it (even if it's the most obvious way), so you're going to commit to that style or choice. That's okay. Sometimes we have to just deliver it the way someone wants it. That doesn't make you a bad actor.

What I'm asking is that you correlate this to life.

I don't plan beats. Life happens. I respond. I naturally take "beats" when I feel overwhelmed. I naturally take "beats"

when I feel something new or I get a piece of news that's distressing. I naturally have "beats" when my boyfriend tells me he's in love with someone else or I find out my sister's pregnant. I naturally respond to a "beat" when there is silence or I'm waiting with anticipation for information. How it makes me feel is a spontaneous reaction to the moment.

I don't plan on saying "Oh my God!" but it comes out of my mouth. I don't plan how to say, "I love you." I don't plan on breaking down crying as I say, "Get out!" but that's what overtakes me.

The beat plays *me*. I don't play *the beat*. It's not the line that comes next. It's the moment.

So as always, if the goal is to make acting like life, just follow the rules of life and you'll stop acting and immediately get real in a non-actor-y way.

Life takes our breath away. Life humbles us. Life makes us laugh. It pisses us off. Let it all come from there — from actually receiving what life is giving you — one beat (or moment) at a time.

Or as two characters in the award-winning film *Boyhood* beautifully express at the end of the film, "You know how everyone's always saying 'seize the moment'? I'm kind of thinking it's the other way around. The moment seizes us."

"Yeah . . . It's constant . . . the moments. It's always right now." [3]

Amen.

3. What is the difference between a "need" and an "objective"? And what is a "super objective"?

Who the hell knows? But here goes.

The word "need" is described in the dictionary as "something wanted or required." The word "objective" is described as "a thing aimed at or sought; a goal." [4]

So at one level, you could think of the word "need" as the end result and the "objective" is the means or the goal through which the need is met. For example, my *need* could be to teach artists. And publishing this book is the *objective*, or means, to fulfill that need.

It sometimes may feel like semantics because goals, needs, desires, intentions, objectives all commingle and become interchangeable in real life.

But in acting terms, let's first look at an objective — what the character is going for in a scene and the means used to satisfy a particular need. The theory goes, knowing what your objective is helps to motivate actions in pursuing that objective in the scene.

For example, maybe I'm doing a scene and my objective is to make my girlfriend jealous. (The "need" is to get even with her; the "objective" is to make her jealous.) What we often do accidentally is play the objective (make her jealous)

throughout the scene, and act out those ideas of what making someone jealous looks like *on the lines*.

But this reductive analysis of the scene is what turns us into one-dimensional actors who "act".

In life I have needs. Or goals. Or desires. But those needs change all the time. Right now, my objective might be to write this response, but while doing so I get distracted, turn on music, surf the internet, and daydream. (All of which happened!) Then I come back to this moment and deal with typing on the blank page. Needs change. And they change based on what the moment gives us and how it makes us feel.

Actors are sometimes taught to look for and add "subtext"; that is, something going on *underneath* the dialogue. So they are asked to say the lines one way while adding subtext — unspoken thoughts and motives — that run counter to the obvious meaning of the lines. But unspoken thoughts are just that — thoughts! Human beings have like 70,000 thoughts a day and unless you're a Zen master meditating in the mountains of Tibet able to completely clear your mind, you are always, always *thinking*! While we are listening, while we are doing (or not doing), even while we are speaking — thoughts are firing non-stop.

So, as you're listening in a scene you're going to have thoughts. Some of those thoughts are going to run *counter*

BOOK THE JOB! (For Teens)

to the meaning of the line you say out loud. But that can't be played. Forget about "subtext" and just let it rip! Don't add more reductive acting terms that put us in our heads and make it more complicated.

Stanislavski developed this concept of "super-objective" to support the theory of stringing together a through-line of actions (I'll get to that later). The argument being, for a character to achieve his super-objective, the character would first have to fulfill smaller units of actions — understood as objectives — to get to the "final goal of every performance."[5] For example, the super-objective in a scene could be "to win back my lover who wants to divorce me." And then my objectives might be, "to seduce", "to guilt", "to flatter", "to titillate", "to provoke", and on and on it goes.

When I first learned to act, my classmates would always talk about the "spine" of the character and the text. That is, the foundation or backbone or "spine" is the super-objective, and the objectives are considered "vertebrae". I'd often wonder, "Am I in the wrong class? Is this anatomy? Are you pre-med? Should I change majors?"

I mean, I guess it's pretty imagery. The spine. But I wasn't able to ever really convert that "skeletal" knowledge into actual experience, because I'm not a doctor (!) and we don't have super-objectives! Or one could argue we do; we just don't call them that. We have goals or desires or intentions or fantasies.

And our day-to-day existence is often filled with trying to vet those things out. But along the way, things change. We lose interest. We fall in love. We change careers. We fall out of love. We discover it's not what we want. We sabotage ourselves. We give up. We stop. We get distracted.

The reason acting has been taught for generations that it's about going after an objective is because scenes inherently are active and they almost always deal with conflict (or set us up for more conflict to come). The argument goes that acting is the art of *doing* and what better way to demonstrate that than have someone go after something.

But acting *isn't* the art of doing. It's the *art of being* first. It's from this place of *being* that we take *action*. If you don't first have yourself *in* the experience, it doesn't matter how well you conceptually understand what you're going for in a scene. It still won't play. Or it will play at the most obvious of levels.

As audience members we feel feelings because of someone in a story is having moments of feeling. Afterwards, we come out the other end of the experience and perhaps say, "That was a story about love or betrayal," but we're not analyzing something or deconstructing why something is happening *while* we're watching it. Sure we're processing information, but we're having an experience. It's happening. And we are witness to it.

The irony is twofold.

1) The inherent need or objective in a scene is embedded in the text, so what someone is after is revealed to us simply by the words. (Yes, sometimes there are hidden objectives or making choices that work opposite what the obvious goal might be, but still, the basis of what an objective is has already been covered in the dialogue. So it can't be played!) *You can't act what's already there!* It's what makes the scene go.

2) Knowing what your objective is doesn't necessarily help you if you don't first understand how to be available to the moment, through active listening and reacting.

 I can't go for something in life at the expense of not acknowledging the moments that come at me *while* going for what I want. My objective may be to get on that plane. But the moments leading up to that might take me in a completely different direction and I end up missing my flight completely. And then my objective will obviously change based on the circumstances.

Furthermore, getting stuck in playing an idea of what something looks like also runs counter to our own complexity of how we often get in our own way of going after what we want in life.

I may have an objective to get a boyfriend, but along the way, I do innumerable things that sabotage, deflect, and divert me and help me lose interest on the way of fulfilling that desire or not. I may want to have an acting career. But along the way, I flake out on auditions, don't show up to class, refuse to prepare, or just stop showing up. And yet my *objective* is to act.

We often stop ourselves from expressing or communicating what we *really need* in life to people who are closest to us. Again, ironic. At some level in certain relationships, we often find it very difficult (or scary) to really tell a lover or a boss or a parent or a sibling what's *really* going on — and this is why we walk around with so much pain and confusion. Resentment and upset. We're too scared to directly ask for what we deserve and desire. We may passive-aggressively hint at it and then get upset that our partner doesn't already know and can't read our minds! "He should know how I feel!" No he shouldn't. But we often let our non-communication of things *be* the communication.

Going after things rarely takes a straight line. Weird, huh? It's byzantine and circular and sometimes we feel as if we're right back where we started. Hence, pursuing what we want in a scene is important, but reducing the way we're going to do that down to an obvious interpretation isn't.

When modern acting was developed through Stanislavski's system, he was giving actors tools to get them to ultimately be free and in the moment and active. But where along our

journey did the means become the end? At some point, you have to discard the instrument if the instrument gets in the way. Or as technology teaches, come up with a more evolved tool!

Understand what the scene is about. Know what the need and objective are, and trust that your body — through instinct and impulse, listening and reacting — is going to be affected by that understanding of what you need and how you choose to get there moment-to-moment.

Fulfilling needs and objectives in a scene can be this simple:

Say. Throw away. Then play.

Or simply, know-and-then-throw.

4. What is my through-line?

Grammatically speaking, a through-line is described as such: "When objectives are strung together in a logical and co-herent form, a through-line of action is mapped out for the character." So, with a script or scene, you are given this blue-print, this map, which is the story, and it has its own internal through-line. A character gets from point A to point Z by the dialogue, circumstances, actions, and other characters *in the story*.

Now, how you as the actor navigate through the story is go-ing to be what's exciting and weird and scary and human and different for each performer. If everyone picks up a script and decides on the same "through-line" and then the most obvi-ous ways he or she is going to get there, it leaves no room for human variability. You end up doing it perfectly or "right" or well-planned or thought-out, but who cares?

Years ago, I was doing a show in NY and I ran into an actor friend of mine who was also doing a play and we got to talk-ing about the process of it all. I'd seen his show during early previews. He said he was still struggling with how to figure out "the character's through-line." I was like, "Huh?"

The play was about surviving the AIDS crisis. The "through-line" was just that — his character surviving the AIDS crisis. Being brave enough to go on in the face of such suffering and

death and rise above the pain and bleakness of it all. That's what I got watching the show. But I never once thought, "What is the through-line here?" I just was moved by the show.

The actor can't go looking for it. Or maybe she can and make a choice about what it might mean for her, but she can't play that. I can't be in the moment overcoming tragedy or whatever I'm dealing with and then at the same time try to illustrate that I'm maintaining my through-line. Through-lines don't need to be "maintained". They *are* the narrative. If there were no through-lines, the story would simply fall apart — no matter what choices the actor makes!

If you listen, you will be engaged in actions moment-to-moment. The listening compels you to speak with feeling and the text you say — strung together with lots of other text you (and other characters) say — will give the audience the through-line!

A through-line is just a fancy name someone came up with to describe the theme of a play. So this play is about never giving up on love. And that play is about the cost of revenge. And this play is about how men and women are never on the same page. The theme of a play might be surviving genocide. And the character's through-line might be forgiving his enemies. But at the end of the day, aren't all these just topics that the play (or movie) itself explores? You can't play any of it.

So read the play, understand it, make a choice of what it means to you, and then get into the nitty-gritty of each moment. The audience will find the through-line believe me. If they can't, it's not your fault. It's the playwright's.

5. How do I find and develop a character?

You don't find a character. It finds you.

Things that can be developed:

> A sense of humor.
> Great abs.
> Fashion sense.
> Film stock.

Things that can't: Character.

Journalist and sociology researcher Malcolm Gladwell might just be the best acting coach *anywhere*. In his book, *The Tipping Point*, he writes, "Character, then, isn't what we think it is or, rather, what we want it to be. It isn't a stable, easily identifiable set of closely related traits, and it only seems that way because of a glitch in the way our brains are organized. Character is more like a bundle of habits and tendencies and interests, loosely bound together and dependent, at certain times, on circumstance and context."[6]

Without discussing "character" from an acting standpoint, he gives us the best acting lesson about what "character" *really* is from a sociological, scientific perspective that explores human behavior.

Basically, it's you. And different "yous" are forged from different circumstances. Period. And those contexts evoke the

many-sided characters out of us. Sometimes we like them, sometimes we don't.

Who you were last night on a first date is not the same "you" the next morning at breakfast with your parents. (At least I hope not!)

Yes, you may explore a strange walk or a foreign accent or new way to live in your body or a handicap or an affected way of talking all while playing a different role. But *you* are coming up with it. The "character" isn't. It's a release *into* a part of who you already are. The work is to go inside and uncover it.

Part of that process is simply trying things. *Just try.* (Or as Yoda would say, "Do or do not. There is no try.")[7] So do it! Explore. Attempt. Fail. Repeat. It's a process where you hone what works and what doesn't in a rehearsal. It comes out of being open to exploring *all* possibilities rather than working from a limited perspective saying things like, "The character would never do that." How do you know? You do things on a daily basis that might surprise you, shock you, upset you, or make you question who you are. (If you don't, you either aren't being honest with yourself or you're living a very controlled life.)

So why can't you allow yourself to be surprised by what you might discover in exploring a role? It's a lot scarier to let the moment have its way with us than to show us a perfectly developed "character".

" . . . Forget your perfect offering
There is a crack, a crack in everything
That's how the light gets in."[8]

— Leonard Cohen

So the cracks are what actually "develop" character, but you have to be brave enough to allow them. It's not playing a one-dimensional idea of what we think a character looks like. You let the circumstances play *you*.

Academy Award winner Peter O'Toole said this when being asked about his Oscar-nominated performance in *Venus*: "I know it's very fashionable nowadays to talk about character and I have heard many, many young actors and actresses talking about character but I haven't the faintest idea what anyone means by it. For me it was a good part in a good story. I love the story and I loved the part."[9]

It's subjective. We (the audience) are doing the work, filling in the blanks of what we think we know or don't know about a person or a story. (Just like life with the myriad judgments we have of people we don't even know.) So a lot of "character" work isn't actually created by you at all. It's created by the people watching you.

Marlon Brando said, ". . . it is the audience that really does the work and is a pivotal part of the process: every theatrical event . . . can produce an emotional participation from the audience, who become the actors in the drama. . . . The most

effective performances are those in which audiences identify with the characters and the situations they face, then become the characters in their own minds. If the story is well written and the actor doesn't get in the way, it's a natural process."[10]

Even if you're playing a famous real-life person, you're not mimicking and then doing an impersonation, nor are you simply believing that you've become someone you're *not*. The insight comes when you realize that if you didn't possess it, you couldn't portray it. (So whether that's Meryl Streep as Margaret Thatcher or Daniel Day Lewis as President Lincoln, they are finding *their* Iron Lady and *their* inner Emancipator *inside themselves*. You simply scientifically cannot be someone other than yourself.)

When Philip Seymour Hoffman won the Oscar for his portrayal of Truman Capote, he was asked by an interviewer on NPR, "How did you study the voice, practice the voice? How did you get it just right?"[11]

Mr. Hoffman replied, "Well, first of all, I don't think it's just right, I mean, 'cause I didn't worry about having it be just right. I knew that it had to be true, which sounds kind of corny, but I knew it had to be honest, and then I knew it had to express the vitality and the nuances of Truman Capote. But, ultimately, you know, no one can just — 'cause that's kind of a mimic thing and that thing isn't as interesting."[11]

So regardless of whether we're playing someone fictional or someone who was a part of our cultural history, what allows us to bring someone to life is by meeting that person through us; within us. Then we discover that *all people* are closer to us than we realize.

6. What about my character's history?

History is just that . . . history.

It's shaped who we are, it's influenced the evolution of our personalities, it's informed us and developed our tendencies. We can learn from it, we can heal from it, we can move past it, but we can't play it. So it can affect us, but it happens on its own. I'm not attempting to show you my history while I'm writing this book. It may or may not come out. Our history is so vigorously a part of who we are that it affects us without our even being aware of it. (Which can also be the challenge because we let our conditioned patterns of behavior from the past interfere with the potential of the present.)

Where acting is concerned, the facts or history of a character is just information. Facts and context, which are good to know, are not things you can show. So if you're looking at a scene and are telling me that the character was put up for adoption at 2 and got pregnant at 15 and ran away from home when she was 18, that's fine. Those might be facts. That's good to know. It's information that might trigger an instinct, but it's not playable. Those facts are either spoken of — or dealt with — in the story itself in *the moment*. The scene is unfolding now. Not when the character was 15. *Now.*

Humanity is more complex than, "I was abandoned at 2 and that's why I act this way now." We may act certain ways directly because of something — but nothing is ever a literal

cause-and-effect association. For one person who's abandoned, she might become very independent. For another, very co-dependent. For another, reckless or abusive or confrontational. For another, alienated or reclusive. For another, loving and maternal. For another, *all of the above.*

Actors become reductive in playing an idea of what something from the past may look like because we can only associate their meaning in black-and-white descriptions.

If it's important history, know it. If you're playing a real-life character from the 1800s, let's say, then of course, read about this person. Do research. What was going on for her at that time? Who was she? What were her dreams? How did it all work out for her? All of these facts might give you insight into how you might create and try things. You might discover for your character that he was shot in the leg and had a limp. So you're going to have to explore your own limp once you start playing. Maybe he was a womanizer. That might give you insight into how you treat women.

But you can't walk around like museum pieces playing some dead aspect of the past. Once you start working, you have to trust that it's a cellular process that may affect you instinctually in the moment — just like your history does to you at times in your own life. Consciously and unconsciously. It may influence your likes and dislikes, your hopes and dreams, your tendencies and behaviors, but you aren't "showing" it. It's just happening to you. The synapses in our brain are firing

at such a rate that they create their own history because they're intrinsically linked to everything that you are and everything you've ever been.

I think sometimes actors romanticize playing parts from the actual historical past. They play ideas of how people walked and talked and loved and fought. I guess the most honest question to ask is, "How do you know? *Were you there?!*"

Yes, people may have worn corsets, or donned powdered wigs. Sure, people drove in covered wagons, and shat in an outhouse. Of course, women's hemlines were below the knee and men slicked their hair back. But isn't all of that being taken care of with the costumes and wigs and sets and makeup and the setting and the location in which the story is being told? You don't have to act it. You can't.

Didn't all of those people back then also struggle with the same stuff you and I struggle with? Love and hope and desire and faith and tragedy? At the end of the day, beyond the superfluous, all people in all times eat, crap, piss, barf, bleed, screw, love, dream, hope, desire, and die. End of story.

Getting into the marrow of that (which is what you in your own life are still living right now!) is so much more interesting than playing "history". So stop trying to show it. Instead, live it. Be it. Be *in you* all the things that these people we might be playing from another time in history had to conquer,

overcome, rise above, and survive. That then will become a *living* history.

The past is always the past. So let history be . . . well, *history*. Because the kicker is, whatever time period you might find yourself playing in — you're still living it *now*.

7. How can I know what the character is feeling if I haven't done my homework?

What homework are we talking about here? Your algebra test? Your history lesson? Reading the first chapter of your social studies book?

Acting. Is. Not. Homework! Nor is character study.

Brad Pitt says, "What we need to be doing is just trying to find truthful moments. I feel like there's too much pressure on this idea of character."[12]

You read a scene (or the play). If it's not written in Swahili, you probably understand what's going on. The guy is breaking up with his girlfriend. The sister finds out she's pregnant. The man is trying to steal a priceless painting. You get the gist of what's going on very quickly. While reading it, your brain immediately makes choices and creates ideas about who that person is. You then get up and you try. That's it.

You can't ever know what the character is feeling until you give yourself the permission to feel what you're feeling *as that person*. If you already know what the character was feeling, we wouldn't have a play. (If Hamlet knew everything, we wouldn't have *Hamlet*.) The actor playing Hamlet is *figuring it out* as we, the audience, is figuring it out. This is what creates conflict in a story. And actually this is what creates story, period.

You don't have the character of yourself fully figured out in life, do you? That's the mystery of being alive and *trying* to figure things out! Without exploration and discovery, we would all be robots moving toward the same end.

The Buddhist monk, Pema Chödrön, talks about our propensity to have everything solved when she says, "We think that the point is to pass the test or to overcome the problem, but the truth is that things don't really get solved. They come together and they fall apart."[13]

I had a student I was teaching in London recently who didn't commit in his scene. I asked him why. He said, "Well, if I had time to prep and really do my homework then I would've committed."

"Was there anything you didn't understand about the scene?" I asked.

Silence. I then asked him to tell me everything he knew about the scene just by reading it. After a long moment, he explained perfectly what the entire scene was about. He didn't need to do any "homework". He did that in 2 minutes! What homework is there to do here? Write a biography about why the character feels a certain way? Show us your intellectualization of what someone is fighting about? The blood and guts of the scene are being evoked in the moment — not in a journal entry of how you interpret the character.

Jesse Eisenberg says this about the over-conceptualization that is often taught to actors. "Acting is kind of difficult to intellectualize — it's a far more visceral experience. It's really hard to be able to think about and then employ these kinds of esoteric notions of this person's backstory and try to weave it in somehow. It's just kind of impossible."[14]

If the actor knows what a scene is about and what's going on and has all the information right in front of him, what keeps him from committing? In this case, his wanting to do homework is really about control because to really have to face the moment (and his partner) and what might come up for him in an unplanned way is too scary and real.

Uncontrolled feelings!

Actors use homework as a default to keep from taking the risk. So they plan, control, come up with clever ideas, and then try to play those qualities. Oscar Isaac says, "How do you play 'righteous'? Do you just stand up straighter? What does that mean as an actor? You don't really play a quality."[15]

So, if we can't play things (or rather, we try to but it creates "acting"), then what do we do with the information about a scene?

Well, here is some "good" homework that we could do.

1) Read the entire play to get an understanding of relationships and context. Maybe even read other plays by that playwright to see if he or she works in common themes.

2) Watch the TV show you're auditioning for to get a sense of the tone, comedy, genre, or style of the show.

3) Read the screenplays of films you've already watched to see the difference between what was on the page and what ended up on the screen.

4) Rent old films and watch the work of classic actors doing work that transcends time.

5) Go see plays and learn, even if the work isn't truthful.

6) Read classic material to get an understanding of the universality of the human condition.

7) And finally, if you booked the job and are showing up on set, of course, you do the homework of being prepared by reading the entire script, having the lines in your scene(s) memorized, and knowing who you're playing and what's going on in each scene.

That's all good, inspiring work to engage in. And common sense. But I'm not even sure it's homework. It's just obvious.

It's called *you care* and you're professional and you know how to do your job.

Other kinds of homework we're taught to do as actors (like breaking down the script and adding our "motivation" on each line, memorizing how to say each line exactly as planned, demonstrating what a prepared emotion might look like, planning out every beat, playing "qualities", etc.) doesn't make us interesting. It just makes us a very good student. And bad actor.

"Busy" work is just that. It keeps us busy and feeling like we're really doing something rather than trying. Remember, at its core, acting is simple. Partly that's because all life scenarios at their base level are pretty much the same. There's love and everything else: conflict and power and fear and intimacy. That's about it. What's not easy is dealing with our own stuff that acting brings up for us. So that's the work. The home-work isn't the work. The stuff that comes up for us in the moment is the work.

When I wanted to learn to ride a bicycle without the training wheels — even though I was very scared at first — I didn't sit in my room writing loads of diagrams and charts and sentences about what riding the bike was going to be like and what I had to do and how it was going to be orchestrated and what it might look like and how I might feel. I didn't write a backstory of where my bike came from or why it was the color it was or how it felt about me or where it wanted to go

or what its history was and how that affected it or how I was going to emote once I was on the bike!

I just got on the bike and pedaled and my dad ran alongside me, and then he let go — and then I crashed. I cried. Then I got up and did it all over again. And then again. And again. I just kept trying until I finally yelled at my dad, "Let go! I can do it!" And I did. And I yelped with excitement and joy. Until I crashed. But each attempt got me closer to being able to ride down the street by myself.

Acting is like that! You can do it. Without the homework getting in the way of the experience and the feeling — which always *trumps* homework anyway.

8. How do I emotionally "prep"?

You don't. You have to trust that there is a part of you that is infinitely intelligent enough to know that everything you have inside you is enough. Because it is and you've experienced it all before in one way or another.

Or maybe Academy Award winner Tilda Swinton puts it better: "When people ask about how I approach a character — well, I wouldn't know how to approach a character if I tried. People will ask about choosing a role; I don't choose roles. People will talk to me about preparation. Aside from putting together a disguise, I'm not aware of any preparation at all."[16]

Gawd, I love that woman!

How do you prep for tragedy? For loss? For love? For desire? For joy? You don't. You experience it when it happens. We don't deal with abstract feelings in life. Only in acting does that happen. Sometimes we have to get to a certain level of feeling in a scene, but that's not prep — that's technique (see previous chapter).

Some things that "prepping" is *not*: It's not about having everything pre-determined and perfectly lined up to match each line. It's not about having everything mapped out and then applying our cleverness to how we're going to say something. That's called control. Or "schmacting." Or playing an idea. Or substituting. Or representing emotion.

What we really need is to be open to the bizarre, beautiful, and unexpected array of feelings that we experience moment-to-moment. If we want to examine the idea of "prep" from this new paradigm of understanding, we can take steps to be more emotionally available.

So here are 10 practical ways you can allow yourself to become "emotionally *aware*." Because if you're not aware of feelings and what to do with them in life, there is no "preparation" in a scene that can take you there. You can't "prep" for something you're not willing to feel in a real way. If it's not true inside you when you're experiencing it, it's going to show up false to us watching. *Liar, liar pants on fire!*

1) **Start meditating.** Science conclusively shows that people who meditate are happier, less stressed, and more creative and fulfilled. Over time you'll be able to call upon emotional reserves you didn't even know you possessed.

2) **Stop anesthetizing yourself from what you feel in life.** It's okay to feel. And only by doing that, do we get through to the other side of what we want in life.

3) **Stop making emotions such a big deal.** They're just feelings after all.

4) **Practice more mindful listening in day-to-day conversations.** Catch yourself as your mind drifts to

your own worries instead of being present with the person talking to you. Get off your own stuff and help people more with theirs.

5) **Notice new things in life.** (Even things we've taken for granted or seen over and over again.) This immediately changes us and makes us mindful. The next time you're sitting with your mom or dad or lover (or stranger even!), notice five things about them. Do it in silence. Sociologist Ellen Langer's research and her "actively noticing things" exercise has yielded profound results. You'll be surprised at not only what you discover about other people, but that noticing things also immediately makes you present and open and generates a heightened sense of awareness.[18]

6) **Take a walk.** Studies show that simply walking releases us from fixed ideas and opens portals into new creative ideas and insights.

7) **See if you can put the phone away for an hour straight each day.** Can you? Take the "no phone challenge".

8) **The next time you're feeling something, describe it to yourself.** For example, "I'm feeling sad. And I feel the sadness in my heart." Or, "I'm feeling anger. And I feel that anger in my chest." Being able to identify

feeling also simultaneously allows us to become less reactive to it.

9) **Mindfully breathe.** When we become conscious of our breath we become conscious of what we're feeling.

10) **Hang out in feeling you don't normally allow yourself to experience.** We all have a set repertoire of feelings that are easier for us than others. Don't like to get angry? Get angry. Don't like to cry? Try it. Work towards allowing *all* feeling to be okay. Because it is.

To be "prepped" in a scene, then, means to start understanding not only what a scene is about (which doesn't take long to ascertain at all), but to be available to *all* the emotional places that scene might want to take you. That takes 1% prep and 99% willingness to stay open.

Like life.

Which is scary and hard. But it's real. And in doing so, you might discover that you're more emotionally "prepped" than you ever realized — simply by being human.

9. What does it mean to be "dropped in"?

To be "dropped in" is to be fully released into our physical body, free natural voice, and emotive core self. The antithesis of being "dropped in" would be acting from our head voice; straining in the throat, muscles, and neck; not releasing our jaw to let out sound; being fidgety or un-relaxed in simply being.

Our natural state is to be "dropped in" but sadly, many of us walk around being completely cut off from not only what we're feeling but also from actually being in our bodies. When you're in your body completely you have an almost secondary sense of your body in physical space and in relation to other bodies. Our physical body *contains* our emotional body. Being dropped is living in our emotional *and* physical bodies together.

It requires us to become mindful of our own bodies and where our feelings live in them. Sometimes they're in my chest. Sometimes in my heart. Sometimes in my groin. Sometimes in my shoulders. Sometimes everywhere at once.

For many of us, we've experienced trauma, which is stored in our body and is too painful to revisit. So we circumvent what those feelings may bring up by numbing ourselves from them. We smoke or eat or drink our feelings down and away. Sometimes we lie to ourselves and tell ourselves everything's fine when it isn't. Sometimes, as a student in Canada once

told me when I asked her how she addresses her feelings in life. Her response: "I don't."

Sometimes emotion is so alien to us that when we actually *are* feeling, we attribute it to something else. "I'm having an out-of-body experience." No we're not. We're having an in-your-body experience. Perhaps for the first time. And if we continue to live in that place more often, we'll find it gets easier and easier to drop in.

Remember, in acting, it's all happening to you. That's it. You try to identify with the made-up or fictitious or "imaginary" world the playwright has written and make it yours. So you're getting punched in the gut. You're having your heart broken. You're falling in love. But it's all experienced as real.

When you're really in your body, your system won't know you're "acting" and that's truly being dropped in.

10. What is the difference between making choices and planning what I do?

Planning = control.

I get why we do it. It feels good (sort of) to be in control. We feel safe. We can exercise an agenda. We can manipulate and feel like we're clever or hit all the "right" notes.

But no one is in control, people! *No one!*

A choice is coming into a scene with a point of view. And there are hundreds of different points of view you can explore in each moment. That's called *letting go* of control and being open. Much harder to do.

It's much more brave to go for something unexpected — even if that thing doesn't work out.

You see a pretty girl at a bar and decide to say hi. You get shut down. You see a pretty girl at a bar and decide to say hi. She says hi back. You see a pretty girl at a bar and decide to say hi. Her boyfriend punches you.

Plan your vacation. Plan for your 401-K. Plan your calendar for the week. Plan on going to see your doctor for a check-up. Plan on calling your mom for her birthday.

But stop planning your acting.

It's okay to let your mind roam and come up with interesting ideas, because it's going to happen anyway. The key is to stay available to things occurring that you couldn't have imagined. That's like falling in love.

So, you will make choices. Your entire life is made up of them; from the type of cereal you ate for breakfast to deciding to move to a new city. But within the sphere of possibility that making a choice creates, we then have innumerable options that each moment presents to us. Saying "yes" to the moment and what it offers *is* making a choice.

As writer P. Lowe says, "I am available for anything that wants to happen in this moment, including that which is beyond imagining."[17]

Hell yes!

You don't achieve that by "planning." That comes from living.

11. What does it mean to be more specific?

To be specific means: commit fully. Express honestly and vulnerably. 100 % of the time. That's it. If you do that you will never be unspecific again.

When you want to tell someone something very personal, for example, maybe it's your ex-boyfriend and you want to say how much he really hurt you. That's specific. Instead, you say nothing. That's not.

When you openly express what's going on for you in any given moment, things get very, very specific. Now it may all come out like mush and be just a really hot mess of feeling — and nothing like how we planned it — but it still becomes specific because you're expressing it. In the moment.

It's challenging because it asks us to really start confronting things we would rather not examine. So we put off, or procrastinate, or rationalize our way through things hoping that in the short term, they will just go away. But they don't. They just keep coming back in innumerable ways until we really are ready to start examining them. Or are forced to.

Carl Jung said this: "Unfortunately there can be no doubt that man is, on the whole, less good than he imagines himself or wants to be. Everyone carries a shadow, and the less it is embodied in the individual's conscious life, the blacker and denser it is. If an inferiority is conscious, one always has a

chance to correct it. . . . But if it is repressed and isolated from consciousness, it never gets corrected."[19]

That doesn't mean we have to have everything solved or be further along than we tell ourselves. It can be radical at first because we spend an inordinate amount of time *not* dealing with what we need to face. But as we start to do so, we discover that life actually gets easier.

If we can all just get a little more honest with ourselves first (collective deep breath), we'll begin to see how rarely we actually are. And that's a beginning and a breakthrough of freedom right there.

12. How do I make strong choices and be simple?

Strong choices are born out of *simplicity*. So you don't have to worry about that. Don't confuse simplicity with doing nothing. The most complex actions in life can be wielded simply. A diver flying off the 10-meter platform. An ice-skater doing 3 revolutions in the air. A quarterback throwing the ball in 2.5 seconds. All these acts are complex. They are executed simply through the law of least amount of effort. (And lots and lots of practice.) When you make strong choices in your life and in your work — they come from a place that is actually doing the complexity for you. It's like asking someone to be complex. Have you seen humanity? It already *is* complex.

Part of simplicity comes from trusting that your choices are uniquely yours and will resonate with the person watching you. You can't second-guess how you do things. When you do that you're in a state of bifurcation. In other words, you're screwed. You're half in and half out. Make a bold choice and see where it takes you.

Obviously, we must fulfill a scene, but I've found that in class and in a rehearsal process, it's not your job to just get to the end result of the finished product. And . . . *scene!* It's about the process of being open to explore what's coming at you and never deciding on something until you absolutely must.

When actors are told they're not making strong enough choices it's partly because they aren't letting themselves express at

deeper and more complicated levels. This sometimes happens because we're scared to make the "wrong" choice so we don't make any choice at all. There is no "right" or "wrong" choice for a scene. There is only truthful or untruthful. Committed or uncommitted.

If you start acknowledging even what you are feeling that day — that moment — and put that into the work, your choices will be strong. Feeling frustrated? Put that into the work. Feeling sad? Let that go in the work. Regardless if it's "right", it will drop the actor *into* something truthful, and it will change.

Kevin Spacey had an epiphany about this truth while doing a production of *Richard III*, "I don't start off a performance going into a corner and trying to become *Richard III*. I've trusted that if I just go out and however I am that day, whatever mood I'm in . . . if I'm frustrated, if I'm angry, if I'm lonely or incredibly happy, doesn't matter what . . . I start there. There is a remarkable thing that happens which is just that . . . I let the play take me there. And it always does."[20]

Anger might transform into upset then into resentment then into crying. Joy might transform into laughter then into frivolity then into crying. In life, we're not attached to the results nor do we stay in one emotional moment. Things move us elsewhere.

Another thing about choices: Your idea of what something looks like and how it's perceived are two different things. That

doesn't mean it's wrong. It just means everything is subjective in the world. For example, your version of being "adversarial" (if that's a choice you're making in an audition) might be conflicted, aloof, or passive-aggressive to you, and come off as cocky or bull-headed or dangerous to the casting director. Things don't read one-dimensionally. And things don't read like we think they read.

So go for something and don't worry that the casting directors might have an idea of what something looks like or what they think they might be looking for. Doing it your way will either fulfill that idea or inspire the casting director to think differently. Or they'll give you an adjustment because they like that you went for *something*, and then they'll see if you can work with the notes they then give you to take you somewhere else.

We all have places we can go to in our work that are easy for us; that are part of our arsenal. That's not necessarily a bad thing. Sometimes that's all the business will ever ask of us — to play roles that are in our wheelhouse, and ask us to do the same thing over and over again. But making strong choices requires us to meet our own stuff and transcend it.

And this is also why acting can be, at times, funky. But really, I think it's the real reason any of us want to do it. To bravely feel. That's what we came here to do. It's as simple as that.

13. How do I play "actions on lines"?

Actions on lines is a theoretical concept to try to get actors activated in their listening to make something happen on a line. But think about life. All lines are essentially neutral — meaning they can have thousands of interpretations depending on the circumstance. So I could be treading water surrounded by sharks and scream, "I love you!" to my partner who's in the water with me. *Yikes!* That line is being affected by what I'm dealing with circumstantially. I could take the same line and be saying it to my lover while we're lying on a beach on vacation. The way I'd say it would be different.

Yorick van Wageningen, who plays the baddie from *The Girl with the Dragon Tattoo*, says, "I really believe that there's something inside of us that's infinitely better at acting than whatever things we come up with. If you let that *thing* do its *thing* then I find that process is the most interesting to watch. You don't have to do anything. I know very often that is scary. I think the reason we create all these different methods of acting is because we're afraid of that *thing*. Can you let it happen on a big picture set with 200 people where something you cannot predict comes into existence? If you try to be in stuff that's immediately uninteresting, you have to have guts. Especially on a big film set to have no idea what you're going to do when somebody yells 'action!' but I think that's what it's all ultimately about."[21]

Bingo!

Lines naturally have action because they are said *in response to* something. If they had no action, we simply wouldn't speak. But since what we hear compels us to say something — that in and of itself creates action on the line.

If you ignore what you're feeling to play a pre-planned concept, then you aren't fully listening and responding to your partner. And what does that create? "*Acting!*"

Lee Strasberg (whose work often got criticized for being "heady") decried the tendency in the actor to manipulate and pre-plan how to say a line and he was against that kind of "scene analysis" at the Actors Studio. "We don't care how much the actor knows here [points to head]. We only care about how much he knows here [points to heart]. We only care about how much he can really live out and how much he can experience. Knowledge, which is not really experience at this moment, is of no value to the actor. In the initial stages of rehearsal of [Stanislavski's] production there had always been a great deal of analysis and discussion which he called 'rehearsals around the table', but toward the end of his life [Stanislavski] said, 'It's no good. The actors have a tendency to talk a lot, and then they don't do anything, but they think they are doing a great deal because they have all discussed it. I don't go in for that now.'"[22]

Don't worry about playing actions on lines. Let your listening generate your feelings and thoughts based on what you hear

and what you're experiencing in those circumstances, and then when it's your turn to speak, your lines (and behavior) will take care of themselves.

As a side note, this might be a good time to dispel one myth about this whole acting thing. A lot of the work we're going to be asked to do as actors can be very reductive, results-oriented, hit-the-line-"correctly" sort of acting. A lot of it really has *nothing* to do with the art of acting at all. And I'm assuming that we can all do that. Because we can.

But let's understand the distinction. When I'm discussing these bigger ideas to have deeper, more meaningful and exciting experiences in our work to create more freedom and greater connection — that doesn't mean all acting is going to be that for us at all times.

The purpose of this book and this dialogue isn't about supporting us in the obvious. It's about opening people to the vast experience of what it is to be an artist and to create things in our work we never thought possible. We can't have all our actions set on each line and at the same time be available to the unknown. There is no chance for the undiscovered then.

Live and act as if on an uncharted adventure, and the discoveries that are sure to happen give our lives (and our acting) new meaning, new insight, new hope, new possibilities. And that itself is worth the ride.

14. If I don't know what my next line is, how do I know what to say? And when I do know what to say, how do I live moment-to-moment?

In everyday situations, I don't really ever know what I'm going to say. I listen to what is being said to me and I respond naturally.

Do that in your acting.

Playwrights write dialogue in a way human beings speak. Chances are if you're really listening under the given circumstances of a play (or film), what you would naturally want to say is going to be the gist of what's on the page.

The whole point of acting is to act *as if* we're hearing things for the first time. So whether we have the lines memorized or are picking up a script cold, the goal is to always respond in a way that is authentic, in the moment, and doesn't suggest we're *acting*.

This happens by listening for the first time *every time*. The Greek philosopher, Heraclitus, said, "No man ever steps in the same river twice, for it's not the same river and he's not the same man."[23]

It basically means every time we're engaging in life (even if it's something we've done a thousand times before), each experience is going to be slightly, subtly, yet tangibly different. The

ever-changing moment does that to us. The same goes for acting. How we listen and react can be a new, exciting, fresh discovery. It can happen through intention or tone or attitude or body language. A person's eyes flicker or their breathing gets heavier, or there is pain in their face or their body slumps. So we pick up on and respond to almost imperceptible differences that are occurring to our partner and to us.

Acting is that simple. That doesn't mean it's always easy. Because listening will stir up deep, often contradictory thoughts and feelings within each of us.

So now what happens once we've memorized something and are trying to have that experience of listening for the first time?

Light bulb: There is never a time when your life isn't unfolding moment-to-moment. So why do we feel this is different in our acting? It's not.

I don't say "hello" the same way every time I say it or to each person I meet. Even though that's a word I say all the time, the way it is evoked out of me has to do with my mood and the circumstances and the person I'm talking to and a number of other factors *all in the moment.*

So it is with lines. Learn them neutrally. Memorize them as rote. Stop thinking that memorizing trumps the moment. It never will. Unless you stop listening and just make it be about waiting for your cue and reciting lines.

Here are some different practical applications for living moment-to-moment, so that the lines will be an expression of what you're experiencing. *Not* what you've memorized.

1) Listen. As if your life depends on it.

2) React. Without censoring.

3) Give to your partner. Without holding back.

4) Receive from your partner. With an open heart.

5) Know the color of your partner's eyes. You should get lost in them.

6) Invent nothing. Deny nothing. (Thank you, David Mamet.)[24]

7) Say "Yes . . . And . . ." (Thank you, Improv.)

8) Before you film a scene, ask to do the entire scene in an improv and then immediately go into the scene as written (and memorized).

9) When having to memorize, just learn everything rote. Add no meaning to the learning of the lines whatsoever. (Anthony Hopkins also gives this advice.)

10) Once the lines are memorized — forget them completely and trust that your body knows them. Because you do.

11) Take the focus off yourself completely and immerse yourself in your partner.

12) Don't get tied to one way of saying things. Say it all in your own words. Or say it in gibberish or sing the lines. Anything to get out of fixed patterns of saying something — and then just listen and go.

13) Squarely stay in the moment fully without anticipating or jumping ahead to the next moment or line which hasn't come yet.

14) Stay open to instincts and reactions that are unrehearsed and unplanned.

15) If you're on the 50th take of the same scene, take a time out and go for a walk and just forget the scene *completely*.

16) Switch roles with your partner (just as an exercise). Ask her if she can say your lines and you say hers.

17) As a warm-up, drill the lines as fast as you can, so that you and your partner do the scene speaking

everything without any kind of pauses or breaks or stops. Then throw it all away and play the scene straight.

18) As an exercise, before you say your line, say what you're *thinking* out loud in response to what you hear your partner say and then immediately go into your written line.

19) A variation on #18 is when you hear your partner's line, react by saying one of the following responses to it *before* you go into your written text: "Yes." "No." "Oh, okay." "I don't know." "What?" You must *really* listen to respond truthfully because not each of the phrases will make sense depending on the cue. However, *all* of them alone are enough to get you through an entire scene.

15. What does "raise the stakes" mean? And how do I "raise" them?

The maestro, Alfred Hitchcock, said, "What is drama but life with all the dull bits cut out."[25]

If a teacher or director tells you the stakes aren't high enough, it just means you aren't living the life-or-death-ness of a scene to the degree in which it's asking to be lived. A play or a film is an exploration of people working through their crap in life-or-death situations in under 2 hours. For most of us, we have a lifetime to work it all out. That's why we're asleep for half of it and take things for granted.

We don't go to the movies or to the theater to be bored. We want to watch people overcoming conflict, moving towards victory, being challenged, surviving obstacles and adversity, and ultimately coming out the other side.

That's drama.

When you're being asked to "raise the stakes", chances are you're playing things too casually. Or you might be playing it as if it's already a forgone conclusion, so why even bother. Or you might decide to not engage because to actually live in the discomfort of it all is . . . well . . . uncomfortable! Oftentimes, actors just give up. Figuratively in their work. And in life.

Investing in what's really happening and forcing oneself to meet the challenges head-on will raise the stakes.

I always tell actors, "Be really, really good. Be really, really bad. Just don't be boring!" Something falling apart and not working (but trying to make it work!) is more interesting than being bland by being too scared to jump in and face your stuff or executing things perfectly. System shutdown is never a viable choice. But fear not. There are ways to get more involved.

Care more. Fight more. Love more. Get more physical. Or you could go in the opposite direction like we do in life to elicit a response in the other person which can raise the stakes. In other words, how many times in life have you ignored someone? Not returned a text? Blew someone off? Been mean or petty? And what does this do? Sometimes it engages the person in a completely different way. They're suddenly all over you and into you and committing to make something happen. Or perhaps it pisses them off and this heightens the conflict.

If you're still having a particularly hard time connecting with certain material and discovering what's at stake in a scene, make it up.

You can make any scenario up in your head — which is something we often do in life, thereby creating drama because it's not based on anything real anyway! — and that might help you engage in the scene in a more demonstrative way.

Your husband's cheating on you.
Your son is adopted and doesn't know.
You're having an affair with your best friend.
You're pregnant.
You're about to run away and get caught.

Perhaps these details aren't what the scene is actually about. But making a choice and applying one of those scenarios to the dynamic of the scene might ignite your passion. The audience will not know what is going on inside your head. We're just watching the story being told through narrative. If your story helps fuel the narrative, so be it.

The wonderful alchemy of acting is that it's coming from so many sources simultaneously. You don't have to get so fixated on doing it a certain way. Or interpreting everything literally. Or adding obvious meaning to each line. The drama of the story is already embedded in the things the characters are saying, so the conflict doesn't need to be played.

You just have to make sure your ass is on the line *living* it. If you do, you won't be told to "raise the stakes" ever again.

16. How do I know how far I need to go before it becomes melodramatic?

If you have to ask that question you're not going far enough.

Is suffering melodramatic? Is pain? Is the loss of your lover? Is the death of your parents? Is being intimate with your girl-friend melodramatic? Or losing it at the longest line ever at the DMV? Is skipping down the street because you're so filled with the joy of being alive?

I guess you could answer "yes" to any of these questions and you then get a deeper answer to your question — all of life at some level *is* melodramatic. We're on a piece of rock being catapulted through the solar system, tenuously hanging on by a thread. That *is* melodramatic, don't you think?

Dum Dum Dum.

Or maybe that's just life itself.

Sometimes, actors will be exploring a different far-out-there character that they have judgments about, and feel that their expressions are "too much" or "over-the-top" or "too big." But if you just take a day and observe life and the people on this planet, you will see that there are some very, very big person-alities engaging in very big behavior.

One could judge it to be over-the-top, but for the person who's living it, it's just how they live. It's survival for some. I

saw a man on the New York subway last year gnawing on the biggest turkey bone I'd ever seen. For him it was dinner. For everyone else staring at him with shock and horror, he had emerged straight out of the caveman diorama at the Natural History Museum.

At one level, larger-than-life characters dwell within each of us. Often we don't let them out — or only do so in the privacy of our home — because we're too embarrassed or shy to express those parts of ourselves publicly.

I think another thing to remember is that if you're truly listening in your work, that kind of deep connection will support even the most outrageous responses. Listening keeps us tethered to the here-&-now and keeps us grounded in the moment. So it's foundational and supports even the wildest of reactions. When was the last time you ravenously devoured a turkey leg on a subway?

Sometimes something seems melodramatic in a scene because the writer has written something in ALL CAPS (!) suggesting the character is supposed to scream and yell, so we do. Maybe we're not actually feeling that in the moment but feel we have to get there so suddenly, we just self-generate those feelings which aren't supported in truth.

I wouldn't call that melodramatic. I would just say that's overworking or "acting" or pushing for feeling. Or trying to play the obvious when you're feeling something *else* instead. Or hitting all the "perfect" notes. "Schmacting."

So perhaps the distinction is letting our own reactions come out of the moment and turn into whatever they want to become in a non-judgmental way.

That's not melodrama. That's just drama. And life itself.

17. What do I do when I'm thinking in the scene, "I don't believe this" or "This isn't working"?

The thought processes that occur when we're acting are the same processes that occur to us on a daily basis. We have thoughts about *everything*. (Right now, stop, and notice the thoughts you've got going on in your head.)

So, in our work, the thoughts you're thinking are really going to be thoughts you have *as this person* you are playing. You are the person!

The circumstances of the scene (when you are living in them fully and committedly) will very likely generate thoughts that take you to the line. (Or actually *are* the lines!) So you might instinctively want to say, "Get out!" and sure enough the line happens to be, "I want you to get out!"

But because of our left-brain tendencies, we also have other thoughts that take us *out* of the scene. "That was a stupid way to say the line." "You look dumb." "God, that's the worst acting ever." "I'm going to get fired."

These thoughts pull us out of the moment and distract us from what's really going on. The more we get committed to the work, the less we'll hear ourselves judging ourselves while in the work.

However, when that happens, there are a number of ways to make them work for you.

1) First, if you pull out and hear yourself saying thoughts in your head that have nothing to do with what you're experiencing and are actually judgments *about* what you're experiencing — the *only* way you can get back *into* the scene is to listen. That's it. There's no other way. You may fall out a number of times, but if you just keep coming back to listening to your partner, you'll eventually get into her world and move out of the world of your head.

2) What you are feeling is *always* the scene. Don't shut them down. When you hear yourself commenting on yourself in a scene, immediately take that feeling into the text where you are stumbling, and let it rip from there. You'll be open to feeling and the moment and the lines. It *is* annoying to hear our left-brain dialogues. You might get frustrated. You might want to scream or shout. If you do — because the feeling is always with it — it will pull you back into the scene.

3) We judge ourselves almost habitually. So we say something like, "You can't do this," because our defaults confirm the negative associations we have with ourselves. That's the vicious cycle of it all. They become an excuse for not going where the scene might make me go. I'd rather pull out and blame it on my mind chatter than really stay in the scene and get into the eye of the storm.

Defaults are just that. A failure to step into what is being asked of us. Our minds tell us we can't do it. Our hearts and spirits tell us differently.

So if you have to listen to any part — listen to the invincible part of you that does know how to do it and also has the tools to come back to the moment when our mindlessness takes us out.

You can if you think you can. And then do it.

18. How do I not care so much?

Not caring comes from the realization that no one will ever have the answers for you. No one will ever be the life-changer we think we're looking for. No job or experience or lover or teacher or vacation or house or job is going to be the ultimate answer you're looking for. Ever.

Because what you're looking for is inside you. It's inside each of us. It's between you and you in this life.

A major block to saying "I don't give a darn anymore!" is that we care so much what we *imagine* other people are thinking about us. The irony is that people *aren't* thinking about us really at all. They're only thinking about themselves — or if they *are* thinking about us they're thinking about us through the prism of how it affects themselves.

In other words, on a daily basis, who do you think about the most? *Yourself!*

You might be thinking, "That's not true, Tony. I think about my kids and my parents." Of course we think about others, but we think about them through *our* hopes, dreams, fantasies, desires, agendas, fears, and anxieties.

Eleanor Roosevelt put it best. "You wouldn't worry so much about what others think of you if you realized how seldom they do."[26]

And yes, that means your boyfriend and your boss and your siblings and your director and your guru and your teacher. That's not to depress you. It's fact. It also doesn't mean we're selfish, but part of our make-up is to take care of ourselves before we can tend to another.

Other people will assist you on your journey. Those who inspire and teach, energize and heal — and listen, too! They come in many, many forms. Ultimately, we're all here to help each other, so it's not about discounting people from whom you can really grow and learn and transform. (And the higher truth is if we get the lesson, *all* experiences and *all* people help teach us — even the ones we most despise or feel were a waste of our time.)

As you become a bit more self-sufficient, you begin to explore *why* are you doing these things? Why do you want to act or sing or dance? Why do you want to tell stories? And for whom? Is it for your parents or your boyfriend? Is it because you have something to prove to yourself and by accomplishing something "big" you'll finally be vindicated and have earned your right to be here?

You have a right to be here and tell your story — through whatever means you wish — by simply being human.

When you do it for yourself and offer it as a gift to the rest of the world, it will be received because it's an act of purity from the heart rather than coming from a place of ego and

fear — "I have something to prove," or "I must get this job," or "I must be on this TV show."

You also allow yourself to have the experience more for the *experience* as opposed to the end result. It becomes less about the external and more about the internal — "What am I holding onto?" "What am I trying to control?" "What can I learn here?" When we start to examine why we hold on so tightly to how we're being perceived and start to do it for ourselves, a vital aspect in letting go comes in not trying to control or pre-determine the outcome and instead be present to whatever happens.

One of the greatest victories is when you come to realize that your happiness is dependent upon you doing things for yourself. That's the ultimate *"Screw it!"* And it's ultimately one of the greatest expressions of self-love.

19. Why is listening so important?

No matter who we are, or where we are, our life unfolds through listening. Every exchange, every interaction, every experience we will ever have is a transference of information: whether that's energy or feelings or physical matter. It's a *receiving* of the moment and all the stuff that moment contains.

Listening is a function of being. It's a function of the ear, but also so much more. It's the gateway into all of our hidden pathways and windy roads. It's the way into the cracks in our heart and the fears we try to submerge. It's the unmooring of our anger and love and joy and rage. It's the connection to something primordial, Divine and otherworldly. It's mysterious while at the same time concrete.

Marlon Brando said, "Listening is being able to be *changed* by the other person. It's not waiting for your cue, it's not 'When are they going to stop, so I can talk?' It's *letting them in*, letting them get inside you, letting them have an effect on you. Then you don't have to act! You listen to them, and they *make* you angry. You listen to them, and they *make* you fall in love with them. It's wonderful."[27]

As we *are,* we then do.

This is presence. This is immersion into the Now. This is listening. This is being. Talking and dialogue come after. If we absolutely, deeply, actively (meaning *with thought*) listen to

what is being said to us in *any* given circumstance, most of what we need to achieve in our acting will be taken care of for us. That's because acting is just *reacting*. But you can't react to something if you aren't listening. The physics make that impossible.

Stop for a moment right now and just breathe. Get silent. Become aware of all that you're feeling. Get in touch with your thoughts. Your hopes for your future, perhaps, or your sadness for the missteps you've made. Breathe again deeply. Feel maybe the tingling sensation of being alive. And also the boredom. This is all listening. Becoming more acutely attuned with our own bodies. Our stillness, the quiet, the breath. Simply becoming aware that we *are*.

Shailene Woodley says she's a "professional listener." And goes on, "If you're in a scene and you professionally listen with the other actors in the scene and you're present in the moment, emotion or the truth of whatever the moment is will naturally be evoked. You don't have to think about it. It just is there if you're truly listening. Just like in my life, right? You react to me based on what I say. I react to you based on what you say."[28]

Two different generations of two wonderful actors saying the same thing.

So listening becomes not only the most important thing — it's truly the only thing. *All* of life's moments are boiled down

moment-to-moment so when we're experiencing them, we're experiencing them in real time. Not yesterday. Not tomorrow. Not in our imagined future. Right now with all the stuff that's simultaneously happening to us at this very moment.

That's so beautiful and so simple. And one of the hardest things to master. It's so profound and life-altering that the TED organization's recipient of the $1 million TED Prize in 2015 was Dave Isay, who invented StoryCorps and discusses in his work how listening is *the* transformational act that has changed his life. "I've learned about the poetry, wisdom, and the grace that can be found in the words of people all around us when we simply take the time to listen. . . . I've learned about the almost unimaginable capacity for the human spirit to forgive. I've learned about resilience and I've learned about strength. And I've been reminded countless times of the courage and goodness of people."[29]

If the world is catching on to the power of listening, actors can be the ambassadors of this revolutionary movement. We can show people how to truly listen and in so doing, radically alter the meaning of our lives. Is there anything more important than that?

20. How do I know I'm following my instinct when it feels like something I wouldn't do in my real life? (Or sometimes asked as: How can I bring more of myself to a role if I'm not like that in my own life?)

In acting — and life in general — we are often in scenarios in which we react in ways that we never imagined we would. We get mean. We lose it. We become humbled. We act out. We let go of control. We become the types of people we never realized we'd become. Sometimes that's a version of our parents. Eeeek.

As I get older, I discover (to my shock and horror!) that I often think, feel, say, and do things that I never thought, felt, said, or did when I was in my 20s. But most of the time, we don't want to look at those "ugly" or "unattractive" or "flawed" parts of ourselves. So that's why we distance ourselves from a role by saying things like, "I'm nothing like that."

Let's get honest. You are.

Who we are and what we experience in life really boils down to fate. Or luck, depending on our point of view. If things were different, *we* might be very different. But it's easier to see ourselves as who we think we are — than to who else we might have become.

When Meryl Streep was asked to do *August Osage County*, she originally turned down the role. "I didn't want to play

this woman who is afflicted by her past and by cancer and by her own worst self. She is detested by her children and quite rightly so. I didn't want to imagine all that and to have to experience it. But my agent kept saying, 'We have to make this happen.'"[30]

And of course she did. (And got an Oscar nomination for it.) By going to those dark, scary, forbidden places within her that she originally didn't want to touch, and that she knew the role was going to evoke out of her.

As we start to work more from instinct (and simply getting honest) and not censor or inhibit the part of us that is often editorialized in our work — we will begin to unearth parts that might be more primal or intimate or aggressive or unspooled. Or other aspects we don't necessarily explore on a daily basis.

Our impulses in our work are really all we have. They are what make each of us unique. And the more we allow them to come to the surface and act on them, the more complex, human, and weirdly wonderful our work will become. Stop using finite labels to define ourselves, or the limited boxes we put ourselves into will eventually become *the* definitions of our work. If we but opened our hearts and minds to *who* we are and *why* we are, we might discover that we could also be a lot of other things, too.

Just because we wouldn't normally do something in life, doesn't mean it's not instinct. It just means we have so many

boundaries, edits, and blocks around parts of ourselves that are instinctual that we often don't ascribe these impulses to our own make-up.

The real work, for the actor, then, is to understand that maybe we don't lead from certain qualities in our life that a role might be requiring, but the potential to explore them dwells within each of us.

If you still can't see that you have an inner lover *and* hater, miser *and* giver, creator *and* destroyer — you're not being honest with yourself.

Ultimately, that's scary for most people because to act on instinct means to act in the unknown. It means to take the leap without any assurance that it's going to work out or lead you to the desired result. But that's not the point of instinct. It's not to have everything "work out." It's to lead you into an experience that's new and exciting and uncharted territory. It's very alive and immediately gives you access to the moment in a visceral, tangible way.

Scarlett Johansson says, "I always come back to the fact that my own instinct is better than something I build in my mind."[31]

Well, that's for sure.

Instinct actually gives us experiences of the mysteries of being alive. It's mysterious to trust a part of ourselves that is not easily understood or explainable. It comes from a part of us that transcends logic or left brain mechanics. This is what's mysterious about it.

In an interview with Al Pacino, Katie Couric asked, "But where does sort of the explosive nature of your performance, where does that come from?"[31]

"We all got that in us. I see it every day. I see it in babies, I see it in animals, I see it in people all the time," Pacino replied. "It's right there in everybody. It's just that actors access these things."[32]

So, let your instincts help you discover and uncover the mysteries within you.

21. What do you mean by "Fake it until you make it"?

Sharon Stone says, "If you act like you know what you're do-
ing, you can do anything you want — except neurosurgery."[33]

Faking it doesn't mean not being prepared. It doesn't mean
that you don't show up in life fully available and as open as you
can be. It doesn't mean skipping steps and taking shortcuts.

It means that in the effort to do anything creative, there is
going to be a level of *not knowing* that requires us to push
through that phase. Faking it gets us there. It's not about
having everything figured out *before* you do something. You
figure things out *while* doing it. That's creativity. And that
sometimes requires a fake.

At one level, there's a whole lot of faking going on every single
day. Everyone's doing it, but we don't realize it because we're
so caught up in the myth that "making it" looks a certain way
and is a final finish line at which we must arrive.

In that illusion, we compare ourselves (and our struggles)
against the ones who don't appear to have any (all the famous,
glamorous, beautiful people of the world!) and then we despair
thinking we're never going to get there. (Wherever "there" is!)

Okay. Take heart. Everyone — and I mean *everyone* — has
along their life's path faked their way through. Vamped.
Punted. Improvised. Made crap up.

I've done it innumerable times. From my early days of waiting tables in New York (Having no clue how to even place an order!) to acting Shakespeare (What the hell was iambic pentameter?) to writing (It took me 8 years to finish my first book!) to teaching (Aren't teachers supposed to be, like . . . 70?) to directing (Can I please give you a line reading?) to relationships (Still a work in progress!) to . . . well, pretty much everything.

The victory comes — as Malcolm Gladwell points out — when you keep going and arrive at "10,000+ hours", which makes you a bit of an expert at what you do.[34]

That's 10 years, people! And that requires *doing*. Not figuring out first and *then* doing.

So in that decade there's going to be some faking. Figuring it out. Falling apart. Putting it together again. Thinking you know and then realizing you don't.

It's called learning.

But you can't arrive at that juncture of becoming a talented actor and confident auditioner, or skilled writer or experienced producer or genius animator if along the way you judge yourself for where you are and decide it's not good enough, so you pack it all in and move back to Idaho.

Things. Take. Time.

You don't have to know everything. You just have to try.

You don't have to have it all together. You just have to be willing.

You don't have to pretend you're someone you're not. You just have to accept yourself for who and where you are.

As you do, you discover that the answers you think are outside yourself are actually all contained within. And sometimes faking it because we don't think we actually possess those qualities reveals to us that for sure — we do.

But this discovery comes only by our willingness to really be out at sea. *Unmoored. Lost.* Sort of like Tom Hanks in *Captain Phillips*, Robert Redford in *All Is Lost*, Sandra Bullock in *Gravity*, Reese Witherspoon in *Wild*, or Liam Neeson in *The Grey*. (Wow, there have been a lot of films recently where the protagonists were literally and figuratively adrift against nature!)

Well, why is that? Because along the way to becoming anchored — when we're feeling anything but — there's going to be a high level of "faking it" and figuring it out as we go along.

It's because of *that* that we eventually get there.

Home.

So fake it . . . and you *will* make it.

22. How do I deal with doing a scene that I'm uncomfortable with?

Academy Award winner Lupita Nyong'o says, "I want to be uncomfortable — acting is uncomfortable."[35]

Welcome to being an actor. It's truly the art of being comfortable while being uncomfortable.

Acknowledging that you're uncomfortable exploring something is part of the process of dismantling the fear. There are all kinds of discomforts being an actor. Just like there are being human. Intimacy, vulnerability, expressing big feeling, physical-ness, playing — to name a few. Doing Shakespeare!

One of the more common fears that actors have is about looking silly or foolish. That fear keeps us from really accessing the stuff we're trying to find in our work. And, to make matters worse, the very thing that we're scared of — happens. In other words, when we don't commit to going as far as we can because we're scared that we're going to look a certain way — we end up looking the way we were scared of to begin with!

Our heads tell us one thing, while our experience proves another. Also, when we really commit, people who are watching go on the ride with us. When we play and have fun, the audience has fun. When we don't commit fully, the audience is either left wishing we would have really gone for it, or they're ambivalent. Or want their money back.

Actors often think other actors are judging them whether they go for something in the scene or not. The truth is we are rarely judging other people's work. Instead, in our own heads, we're trying to figure out how we would tackle the same scene. Or we're simply processing information and watching story be told. People aren't judging us the way we judge ourselves.

Sometimes our mind takes the worst-case scenario that could come out of a situation and plays it over and over in our heads until it takes on mythic proportions. The best way to handle that — and anything in our heads — is to take action. Play ball. Get in there and work it out. As you do, you'll see it's not that scary.

The other thing you can do with the discomfort is express to your scene partner what's going on for you. Or a director or producer for that matter. If you're attempting a scene that you know is hard or is going to require you to let go or step into something foreign to you, talk through it. The communication of it helps us realize that we're not crazy for having the concerns — we might even discover that our scene partner is feeling the same apprehension.

Acting is about solving problems — because problems will inevitably arise.

So, if you're doing a scene that is intimate (as this seems to bring up a lot of stuff for people), how do you work with

your resistance? Where does it come from? It might be body issues, it might be the awkwardness of it all, it might trigger your trust issues, it might be about exploring a physical part of you that you don't even allow in your own life. What's so scary about it? Why does it feel confrontational rather than exciting, adventurous, and mysterious?

Sometimes it's about shifting the way we hold things in our heads. Could it be breathtaking? Could it be wonderful? Could it be exhilarating *and* scary? Could it be all these things and could it also be that that's also worth exploring in itself — why we want to be creators and go to places we never thought we could go to before?

So, you acknowledge. You breathe. You take it step-by-step. You remind yourself that it's all exploration and that you don't have to have everything solved or perfectly presented. You talk about what's going on for you. You ask for help. You try not to fast-forward and get ahead of yourself. You share. You give yourself the permission to try something that scares you every day (or at least once in the scene each time you get up to do it). You differentiate between "unsafe" and "new". Just because something is foreign to us doesn't mean we have to define it as "unsafe" or "scary". You celebrate and honor that you're at least attempting to do things that are new for you.

And anyway, isn't that the whole point? As Tennessee Williams said, "Make voyages. Attempt them. There's nothing else."[36]

23. Why do I stop breathing?

Well you don't, really, because if you did, you'd be dead.

Good to know.

But as we experience big feeling — in life and in our scenes — we do tense up; our shoulders seize up to our ears, our bodies tighten, we clamp down on our chest, we hold our breath. Part of this is a natural defense to brace ourselves from the trauma or emotional blow we're about to experience. This is what happens in life — we get tense and anxious around intense feeling and forget to consciously breathe.

When we act, we are really just doing what we naturally do in life. So the challenge is to be a bit more conscious of those defense reactions that keep us from being relaxed while feeling feelings that make us uncomfortable.

It's counterintuitive because the acting process asks us to be that which we rarely allow ourselves to be in life: open and stress-free when it comes to conflict, pain, upset, and turmoil. Just those words themselves create tension. But the first step to access feeling in our work is to breathe into them. It's a conscious choice.

I was on a flight recently that experienced heavy turbulence. I had to remind myself to breathe deeply. Move my energy

from my head and fearful thoughts to actually being in my body and breathing through the feelings. This was in between me pushing the call button and screaming to the flight attendant, "Is this *normal?*"

We aren't taught how to breathe mindfully in life. So it takes time to get our hearts and minds and bodies around what it is to do this in our scenes.

When you have a physiological response to something, immediately notice your breath. Breathe deeply to restore your own connection to your awareness and your body. When you do, you'll realize you aren't breathing fully, then naturally you'll have access to the feelings that our shallow, panicked breathing doesn't allow.

Or as Bill Murray succinctly puts it, "The more relaxed you are, the better you are at everything."[37]

So just breathe.

24. What about Imagination in the actor's process?

You have one. We all do. You're using it all the time. Sometimes consciously, sometimes not. How and when it's needed in acting is simple.

You can't be *imagining* something while experiencing the moment. You have to deal squarely with the moments as they're coming at you. You can't imagine what the "character" should be sounding like or imagine how a person might say something when *you* are actually dealing with saying the lines as you experience them. Now. *But* you can use your imagination in ways that free you up to the moment.

We don't need for you to turn your imagination off. We need it! It fuels our creativity and gives us ideas to play with and explore. It might inspire us and give us the permission to try something we'd normally be too scared to try.

Our imagination might help us see ourselves as this woman or this man with a different voice or a different way of walking or talking. It might give us the freedom to explore something so alien to us we only *imagine* it happening, since to do it might require great bravery or commitment. It can inspire us to dress differently or cut our hair or explore an accent because those things might feel right for us to attempt in a rehearsal.

Imagination is powerful. But once we come out of our vision for our future or our positive daydreaming exercise, imagining our intended future, or simply spacing out and thinking about someone we just met — reality comes crashing in on us and we have to deal with what's right here, right now. We don't have to imagine pain and suffering and joy and love and possibility and excitement. It's all around us. And inside us. And in others. And in experiences. And in our primordial connection to self. To our histories and who we are.

Acting is the same. So, let your imagination inspire you to go for creative things. Let it elevate your thinking and keep you searching for more. But don't force your ideas onto the moment. Trust that your imagination has something to do with your self-expression, because it does. As you live more in the "Yes" of the moment, you'll discover things you never could've imagined. And that is more exciting than fantasy any day.

The Heart

1. How do I become more vulnerable?

Vulnerability is the natural state of being human. It's the essence of who we are. And yet, we will spend most of our lives trying to *not* be who we essentially are.

It's understandable. We've been punished. Heartbroken. Betrayed. Lied to. Abandoned. Ignored. Rejected. Shat on. Denied. Made fun of and pretty much discarded.

And that's all in one day!

Experiences in life shut us out from our natural state. We begin living as a sort of self-defense mechanism. It's called survival. At extreme ends, it's literally survival — like for people who live in war-torn countries. For the rest of us, we push through our days closing ourselves off from others and what we feel. This is a sort of self-alienation.

The easiest way back to vulnerability is to allow. Start noticing when you shut people out. When you respond negatively. When you get scared and clamp down. When you control and exercise agendas. What would it be like, instead, to just breathe? Breathe into what we're feeling. It might be nervousness or discomfort or sadness or fear.

Just that awareness, that recognition and allowance to not cover up or hide what we're actually feeling — and instead breathe into it — is a way *into* vulnerability.

Oftentimes, actors get stuck at the superficial level of what they think vulnerability looks like. I think a lot of people (actors especially!) equate that with crying. If I cry, I'm vulnerable. Ummmm . . . haven't you heard the phrase "crocodile tears"?

It's not about crying or getting to any specific emotion. Vulnerability is staying open to being exposed nakedly to our own fragility of simply being human. That comes in innumerable forms.

For one person, it might be intimacy. For another it might be getting angry. For another, it might be looking at why she laughs uncomfortable moments off. For someone else, it might be about letting down his guard. For someone else it might be about simply being still.

We become more vulnerable in life by moving past the obvious of what we think vulnerability looks and feels like.

I've felt just as vulnerable falling down on the street as I have looking into the eyes of a newborn or hearing the news of a tragedy.

Vulnerability is letting go of control. Period. (Or rather when we have the "Ah-ha" realization that we actually have zero control in life, and that the things that make us feel like we do are all an illusion.)

That's scary. That's why we feel vulnerable.

The irony is that life is going to make us go there anyway. We must surrender to life. Being open to our connection to something greater *is* vulnerability.

From joy, intimacy, personal victories, and adventures to loss, decline, fragility, poor health, and ultimately death, life shows us that vulnerability isn't something to be scared of — it's a vital part of our experience.

I think the better question to ask is not "How do I become more vulnerable?" Rather, "How do I stay open to new experiences and new feelings that scare me?"

Academy Award winner Juliet Binoche discusses the real work of an acting teacher and the art of being open when she says, "It's about opening doors. It's not really about teaching. It's about finding the place where it opens. A lot of actors want to act and prove that they're actors. The teacher is there to show them that you don't have to act. You have to open up, and be. The being . . . [is] more interesting than anything you can try to do. It comes through you; you allow life to come through you. It reveals itself because of you, of course, but it's the ability to open up to what it is."[38]

That's what vulnerability gives us when we surrender to it. Opening up to what *is*. No matter what that *is* is. That's not just the way into acting, that's the way into a new, exciting life that's just waiting to be discovered.

2. How do I start recognizing how I really feel?

We always recognize how we feel. Always. What we choose to do is ignore it or shove it down or repress it or deny it. We reach for our phones or food or alcohol. We call someone and talk about other things. We turn on the TV or numb ourselves online or distract ourselves with busy work. So it's not a question of recognizing it. Our feelings are as real to us as our hearts.

Recognizing feeling is becoming aware of when we act out to actually *not* have our feelings about things.

Like anything, it's a process. The goal is to not beat yourself up for where you aren't. Some days you aren't going to want to feel. It's natural. There's nothing wrong with having days where you just want to check out for a while. That's what Netflix is for!

Recognition of how we feel comes from doing just that. When you get angry talking to your dad on the phone. When your boyfriend says something that upsets you. When you feel an unexplainable sadness. The work is to acknowledge what you're feeling. Sometimes that's all you have to do. Nothing more. The awareness itself changes our relationship to it. Understanding the feeling will show you how to deal with it. It might show you that it has less to do with the person you're upset with and more to do with your expectations or blame or frustration with self. Or, you might see that you have a valid

reason to be upset with someone. You might need to call them and tell them how you feel. You might just forgive them and let it go.

Instead of being held prisoner by the feeling — which sometimes happens for days or weeks — we instead go directly to the source by acknowledging, "I feel tightness in my chest whenever I think of that person."

Other times, it might be enough to have the feeling. When I went through a bad breakup a number of years ago, I remember being overwhelmed with grief in a way I'd never experienced before. The loss, the discomfort of separation, the being forced to let go, the acknowledgment of being left for another, the complete abruptness of one day it's going great and the next day it's all over — was all a shock to my system.

My breakthrough occurred when my friend (and fellow AMAW Master Teacher), Lindsay Frame, told me that perhaps I didn't have to label my feeling as "pain" or "loss" or "grief" or "bad", but instead just let it be what it was. So I just let the feelings wash over me. I welcomed them in a new way that was still painful (and terrifying!), but I felt as if I had less resistance to them when I refrained from labeling them in a negative, reductive, confining way. It was what it was. And my body needed to do what it needed to do.

That's the thing about feeling. Ultimately, it's neutral. It's this energetic expression of emotion inside us that's catapulted

outwards as "feeling". But what is it really but just tremendous outbursts and expressions of energy. We name feelings as "joy" or "hate" or "rage" or "bliss" but really feelings are just *energy in motion*. E-motion.

We are energetic beings who have more awareness about ourselves than we realize. So trust that you do know how to recognize what you're feeling more than you think you do. The work will be in deciding what you want to do about it. One of the breakthroughs occurs in stopping the judgments we have about feeling.

In a culture that's constantly asking us to be "happy", we often feel guilty when we feel anything but that because society is telling us we shouldn't. But that's not what true feeling is about. Happiness isn't about the avoidance of something else. It's not about ignoring our pain to put on a happy face. That's dysfunction. *All* feeling is valid and important and needed. That's what it is to be human. It's about inclusion. I can feel happy — or maybe joy is the better word — while still being upset with my friend. This is because joy comes from a deep gratitude of awareness of being alive. It abides within us.

Expressing ourselves, then, is freedom. And emotional freedom is joy.

Marlon Brando said this about feelings, "George Bernard Shaw said that thinking was the greatest of all human

endeavors, but I would say that feeling was. Allowing yourself to feel things, to feel love or wrath, hatred, rage."[39]

Although we won't always be comfortable with what may come up for us, the alternative is to live a life as an emotional zombie. Shut off from the world. Risk-averse. Numb. Anesthetized. And *that* is a lot scarier than any kind of feeling we could ever have, for sure.

3. How can I be kinder and less judgmental with myself?

It's sort of like the famous question, "How do I get to Carnegie Hall?"

Practice. Practice. Practice.

We don't have a lot of experience doing this because we live in a culture that doesn't really help us to understand that self-soothing —being gentle with ourselves — is not New Age phooey, it's science. And it's essential.

That act of love and sensitivity to yourself allows you to be more open and caring and patient with others. It allows you to access more creativity and joy. It is actually the essence of being optimally creative.

It's called being an empath. And we must try and recognize when we aren't being that to ourselves: empathetic.

So we have to start with self and remind ourselves to not be mean to ourselves when it's often what we are best at doing..

And now for the can of Whup Ass:

The only thing making you unhappy is your own thoughts.

Change them.

To become less judgmental of self is to first see what the pay-off is in thinking negative thoughts. We often don't let go of bad feelings because it sometimes feels good to feel bad, because that's what we're accustomed to feeling.

Bad.

It seems so counter-intuitive. Why would we want to feel bad? Well, feeling bad about ourselves confirms our own destructive self-dialogues we've been listening to for years. So the entire feed-back loop in our heads becomes a self-fulfilling prophecy. If we tell ourselves things that make us feel like crap, then feeling crappy continues to trigger that part of our brains that tells us nasty things. You see how it works? And then our system becomes accustomed to that feeling. It's akin to a Pavlovian addiction.

Or in modern terms, it's the equivalent of our dopamine level being charged every time our phone goes off and we hear the "ping" or we get a text or email. Our system gets a charge — a sort of reward — that we become addicted to. Our habituated selves don't really care if the information we tell ourselves is negative or not. If we're conditioned to hear it, that's the payback right there.

But new neural grooves can be formed. And through practice we can achieve positive results.

Moving past self-judgment means loving ourselves uncon-ditionally. We've been taught to not like parts of ourselves

because we've been told it's not okay to have them. So we shame ourselves for having thoughts or parts of ourselves that aren't just sweet and nice.

It's like owning a puppy who engages in some naughty behavior that's frustrating at first. Eventually, though, we see them for what they are: these lovable, loyal, fallible, beautiful, friendly creatures.

We need to see ourselves that way. We make mistakes. We err. We do things incorrectly. We fail. That doesn't mean we're a "jerk" or "asshole" or "stupid". The difference between guilt and shame is that in guilt we feel bad for committing an act; doing something that wasn't well thought-out or was impulsive or reactive. And we realize that we can do better next time. Lesson learned. Let guilt go.

But sometimes we then also call ourselves names. We're a loser or screw-up or dumbass for doing it — which moves us into shaming territory. That is, when we shame ourselves, our actions identify us *as the act*. So, in our minds, we actually think we are an asshole, douchebag, or bitch.

When we learn to separate the actions from how we identify ourselves, we become more aware of where we err and how to fix problems. We become accountable for the ways we make mistakes, but we don't demonize ourselves for making them. We're more apt to clean up our side of the street and see ourselves more accurately.

So . . . practice.

It takes some time and certainly effort because no one can change your state of mind but yourself. The more you focus on self-correction (without berating!), you'll begin to see the results. You'll break long-standing patterns of behavior. You'll gain insight into your inner saboteur. You'll become less judgmental of yourself and others, and eventually, you'll stop sweating all the small stuff that your mind has tried to make into big stuff to distract you from what you already know. Which is: you're actually amazing and can do it.

4. How do I know if I'm surrendering fully?

Our natural state is of surrender. We are born into — and will depart from this earth — in a state of surrender. Or rather, our bodies and minds might go kicking and screaming and resisting and fighting, and yet the ultimate passages and transitions are all about letting go. Isn't the final, ultimate act an act of total surrender?

Of course it is, otherwise we wouldn't depart.

We engage in moments of surrender more often than we realize on a day-to-day basis.

When we breathe. When we unclench our fists. When we smile. When we feel happy for another person's successes. When we stop worrying. When we allow. When we receive. These are all acts of surrender.

Our ego wants to keep us in control all the time so the act of surrendering sometimes is a willful and conscious choice.

We don't do it fully ever, because relinquishing control means to have an absolute trust that everything is going to work out and that we're provided for, and that we're safe, and that there's some guarantee that we'll have an experience after we're gone.

The beautiful and yet most maddening (and sometimes overwhelming and scary!) aspect of life is that it's constructed in a

way that we will never know until we do. Or rather, we can't be sure until we do.

Because of the inherent chaos and unpredictability of the moment, human beings like to control because it gives us a semblance of belief that everything's okay. Control doesn't mean it's okay. It just means we feel *comfortable in controlling things.*

Often life does it for us. We get ourselves worked up about a casting opportunity and are feeling on edge, so we finally just say, "Screw it!" by booking a vacation, and then suddenly we get the phone call that we booked the job.

Why does this happen? Partly because our own control of things — and the desired outcome of how we want things to play out — keeps us oftentimes in opposition to that which we actually want. So what we desire is held in abeyance because we can't simply let the natural order of things take the shape they're intended to take. That's trust. And that's also having a strong intention and allowing the details to be taken care of for us.

The art of full surrender — which we aspire to live in —requires the awareness of when we *aren't* surrendering. It asks us to breathe into all of the feeling that's going on for us. It's that simple. Surrendering fully is really a breath away.

So, when you feel yourself getting tight and constricted, when you stop breathing fully and experience tension in your body,

just mindfully breathe. That begins the first step in loosening the controls that get put into place when the moment is actually asking us to allow and receive and surrender instead.

I don't think we can ever know if we're fully surrendered, because there's always going to be a deeper exploration. So, for example, we can love more deeply. We can serve more fully. We can express more simply. But those things also ask us to keep peeling away layer after layer until we realize there is no ending to get to. There is no "final" love. Or final compassion. There is no final surrender. It's always moment by moment.

"I'm holding on here. What would it feel like if I let go?" The fact that you can ask the question about surrender — and know when you're not doing it — shows that you're certainly capable of it and probably doing it more often than you realize. And within that surrender, there may be a new discovery — and then another and then another and another. And that's exciting.

5. Why is rejection such a big deal?

Here's 5 (!) great light bulbs about rejection:

1) You *will* be rejected.
 For sure, lots of times, for being who you are. That's the risk you take being fully invested in your own life — in love, in acting, in dancing, in putting yourself out there, in painting, in singing, in all forms of creating. You are constantly revealing who you are and giving a part of yourself away in everything you do, and that might mean that some people just won't get you or like you or be interested in you or respond to you.

 So what? Forgot them. You're not doing it for them. You're doing it for yourself. And when you really start to live in that truth, you won't care what other people think because there's no greater gift than giving of yourself, with the risk that in doing so you might be rejected.

2) Since rejection is a part of life, you're going to be rejected whether you're "schmacting" something or not. So, I guess the question is, do you want to be rejected for phoning something in and not being honest, or do you want to be rejected for trying your best, committing, showing up in a brave way, and going for things and having a great time?

I'd choose the latter. Not only will it hurt less because you know you're doing everything you can. But also, you'll simply feel better about yourself because you were honest and didn't opt for tricks or take the easy way out or rely on your gimmicks. That's a victory.

3) That feeling of rejection is hard-wired in us as a species originating from tribal culture. Surviving was all about being part of the pack. Get thrown out of the pack, you don't survive. *Gulp.*

No one wants to be cast out. No one wants to be shunned. No one wants to be alone. But I've discovered that sharing our stories (and the feelings that come with them), not only liberates us from the judgments we often have about ourselves, but also heals us by the simple act of sharing. They're not acts of singularity. They're acts of the collective, because we all come from the same tribe. We collectively need to express in order to heal and learn and grow.

4) You're not scared of failure. We fail every day. Our lives are littered with failures. We're afraid of being seen, because being seen carries with it the risk of what we're talking about in this chapter. Not doing it "right" reminds us that we are imperfect. Showing people who we really are means facing the possibility of people not liking us for their own reasons.

5) What we're really scared of is our success. How powerful we can be. And how magnificent and beautiful and competent and talented we already are. We're scared of success because counter-intuitively, it means, once again, that we face the possibility of being rejected or not liked on a grand scale. It means putting our private selves out there in a very public way. It means stepping into a new you — and a whole new paradigm — that our egos are invested in keeping from us.

Success equals overcoming the dialogues in our heads that tell us all the reasons we aren't, and can't be, a success. Facing our destructive dialogues to prove otherwise. And to step into the possibility that it is better to attempt, to risk, to be seen, and to fail than to not be seen at all.

What would the world be like if you weren't seen at all? Ask yourself that.

It would be a very sad place. We need you. Remember that the next time you think you're scared to fail, or worried about being rejected. And then maybe you'll realize that making yourself invisible is a worse kind of rejection: Rejection of self.

Keep rejecting rejection in favor of being the most truthful and decent and present person you can be. That quest will never end and that's the real journey we're seeking.

6. What am I so scared of?

Well, what are human beings *not* scared of?

We're scared of people and feelings and sharing and intimacy and looking weird and being found out and being seen and failing and not measuring up and being rejected and vulnerability and thinking the rest of the world will see how badly we often think of ourselves. And of course, death.

And that's on a good day.

All of these qualities are part of being human and being brave enough to step out into the world with something to say.

They're also a part of what it means to be a truly authentic actor.

If there is one thing I want to help actors understand, it's that there's nothing to be scared of. Our work is a work of joy and hope and light and possibility, and we're all in it together. When people set out to make projects, they set out to make the best possible creation they can achieve. That means they want you to also be your best.

When you book a job, that's one permutation of someone liking you. That's why you booked it. There's nothing to be scared of. And sometimes they love you and you won't book. That doesn't mean you haven't made fans or they won't bring

you back in. It just means for this job they found someone who was more suitable.

Understanding that fear — False Evidence Appearing Real — can stop us from moving forward when we believe the things we tell ourselves in our head is already a step of awareness. It might also help to understand a bit of the science surrounding performance.

We often misread creative opportunities as something from which we need to protect ourselves. This is partly the nature of being vulnerable. And it's partly caused by our own genetic predisposition to fight or flight.

Neuroscientist Stephen Porges talks about the vagus nerve in Frank Partnoy's wonderful book, *Wait*. In it, he explains that the vagus nerve consists of two fibers that connect our brain to the rest of our body. One track is reptilian, and in times of stress controls our guts — our "flight" or "freeze" response — while the other is mammalian, and tries to mobilize us and prepare us to "fight".

Interestingly, both vagus nerve fibers are connected to, and affect in various ways, the heart. Most notably for our purposes, the strength of our heart-brain connection — and our capacity for emotional connection and empathy and feeling — is affected partly by our vagal nerve's "tone" or flexibility (in other words, how fast or slow our heart is beating) in times of stimulation.[40]

What this all means to the artist is that in times of real or *perceived* stress — going into an audition room, having to perform, giving a lecture in front of hundreds of people, doing scene work that brings up huge amounts of feeling, getting rejected by an agent, finding out your girlfriend is pregnant — our body has a physiological response that can often shut us down or basically over-stimulate our system.

In non-scientific terms it's called *freaking out*! We inaccurately perceive different forms of acting as something we need to shore up against, just like our cavemen ancestors did when they legitimately reacted to a threat. In our minds, the casting director of today is the Tyrannosaurus Rex of our ancient cousins.

But we have a natural, neutralizing, and stabilizing instrument within each of us that can normalize and reduce the amount of stress we perceive (whether real or fictionalized) and react to: The breath.

That's right. We've discussed it already. We do it naturally — or rather the mechanism does itself automatically (*Thank Gawd! One less thing to worry about!*) — but a lot of our emotional breakthroughs occur when we learn how to become more mindful about the breath and let it work for us even more powerfully than it already does.

The next time you're feeling triggered and scared, breathe and ask yourself these two questions.

1) Why is it *not* okay to let go of the fear? (You may discover some surprising explanations of how the fear is protecting you, while at the same time, ultimately holding you back.)

2) What does this fear want to show me? (If you're brave enough — and willing to listen — there is great insight into where you may get stuck in life and how to overcome it.)

In the 1950s, Fritz Perls, the founder of Gestalt therapy, said, "Fear is excitement without breath."[41] So remember to breathe, and imaginary fear will dissipate.

Or as Jill Soloway, the creator of *Transparent*, said in a lecture about the nature of the business and how people's first reaction is often based in fear, "Reverse the polarity of the experience. In a world where the rallying cry is, 'We're running out of time, we're running out of money, we're running out of light,' I operate with the feeling that there is plenty of time and plenty of money and light is everywhere, bouncing off of every surface."[42]

7. What happens when life imitates art and I start to have feelings for my co-star?

Chemistry.

The attraction/repulsion force at play amongst all things in the universe. It's science and it's also personal.

Things can get intense when creating with someone in an intimate way. This is one of the amazing things about what it is we do for a living. We're thrown together with a bunch of strangers and are asked to create madly, truly, deeply — and oftentimes, after the experience, we have forged long-standing friendships. We've created real relationships with people we care about in a relatively short period of time. There are people I did shows with in New York 20 years ago that I still keep in touch with. That's a wonderful by-product of a life in the arts.

And obviously, sometimes, we can start to feel things that seem to be harbingers of being "more than friends."

First off, feelings are going to get triggered regardless. Chemistry is real; it exists. And it cuts both ways. Sometimes you're going to love the people you work with; sometimes not so much.

Connections with people are normal. Stop beating yourself up for having them. It's natural. It's also a testament to being *in* something so fully.

Sometimes people have huge connections with their co-stars and end up marrying them and having beautiful lives together. Other people have huge connections with their co-stars, act on them, and then once the shoot is over — and they're back home — see the experience more clearly for what it was. A fling fueled by the passion of the moment.

Neither is good or bad. They're all just experiences. It doesn't make you a bad wife or partner or lover or friend. It just means you're having an experience with someone. We can have experiences with a stranger walking down the street — however fleeting — that can stir up the same stuff and create scenarios in our heads. It's called being alive.

So when the heat's on (or so it seems), how do we keep ourselves present enough to distinguish "actor life" from "real life"?

Breathing consciously to come down from the stuff that happens on set helps us to get out of and move beyond the chemical stuff. Breathing connects us back into our body and helps us realize where we are. Talking to a friend. Getting a reality check. Realizing other people may be involved. Figuring out if it's a pattern.

Acting is a calling to be more honest. And because it requires almost a heightened sense of awareness and presence, it affords us many gifts in our own "real" lives. Perhaps these acting experiences can highlight an appreciation and recognition

for what is exciting and wonderful in our off-set lives. Or if our real-life relationships are in need of some tender loving care, perhaps our on-set experiences can help us to incorporate the spontaneity or creative flow in our entire life and not just leave that on set.

There is a Buddhist saying, "Before enlightenment, chop wood, carry water. After enlightenment, chop wood, carry water."[43]

It basically means that as we become more present to our own lives — and enlightenment at one level means simply waking up to each moment — we realize that we can start to wake up to more and more of our life events. Our lives — even the mundane aspects of it — can be lived with as much vigor and passion as the stuff that we think is extraordinary.

The experiences don't change. Our awareness of them — and relationship to them — does.

When it comes down to the end, anyway, it's all extraordinary. That we were here, had the experience, and touched people's lives and were touched.

8. How do I deal with doing a romantic scene when I'm in a real-life relationship?

Laurence Olivier allegedly once said to Dustin Hoffman, "Try acting, dear boy, it's much easier."[44]

This was in response to Mr. Hoffman apparently staying up 3 nights in a row to shoot a scene in *Marathon Man* because he wanted it to be realistic. When Olivier got to set and saw Mr. Hoffman looking ravaged, he said his now-famous line.

Not sure if it's true or not, but it's a great story. And it sort of answers the question about real life vs. "acting."

Our jobs as artists are really fun and really a privilege to partake in. But they're just that. Jobs.

It's not the end of the world. We're not curing cancer or doing brain surgery or solving a crisis in the Middle East. Instead of putting on a suit and going to work counting money at a bank, we get to wear our pajamas and play with other people in their pajamas. So it's always, at some level, not real.

Yes, the goal is to be living in the moments as truthfully as possible, and as we do, our systems — physiologically, emotionally, psychologically — don't really know they're acting because you're living it that truthfully. And yet. You will always know — some part of you must always know — that you are acting. Otherwise, you're not in reality.

I think the question that is being asked is actually *two* questions.

QUESTION 1: How do I do a romantic scene if I am in exclusive/monogamous relationship?

As we've discussed, chemical reactions can happen when you're working with someone intimately. But that doesn't mean they'll continue after the director calls "Cut!" And you always have a choice to create boundaries if they do.

Yes, acting creates an environment where real intimacy and trust must be engendered for the artists to do their best work and feel safe in doing so. Our "job" asks us to deal more intimately with others in an artificial setting, but the point is you've been hired to do a job. Do it. Be professional. And you'll be able to create boundaries so that you can leave it on set and understand it's just that — something to be explored on set to fulfill the role and the story for the director.

Doing a romantic scene could bring up stuff for you in regards to your relationship, and even point to things that aren't working. Everything is an opportunity to look more honestly where we are in life.

QUESTION 2: How do I get my relationship partner to understand that it's not real?

The first thing you can do is help that person understand what something does — or doesn't — mean. Sometimes

people think that those two actors in a steamy scene must have really fallen in love, had a connection, or had an affair (!) to pull off that chemistry. But like most things in the business, it's not nearly as glamorous and exciting as Hollywood makes it out to be. So explain on-set intimacy to your partner.

It's often technical and awkward and just like any other scene, except you moan and groan a lot. When the crew sit around staring at you and you're half naked and the director calls out, "Move your leg more to the right! No! More to *his* right! Higher! Now lower! Now open your mouth. Not that wide. Just purse your lips. And look into each others' eyes. No! You're squinting. Now moan!" — is there anything sexy or romantic in that? Not at all.

Sometimes you and your co-star have *nothing* in common. There is *zero* chemistry. That's really then going to be "acting" when you have to make something *appear* as if you're hot for each other. Sometimes your co-star will become like a best friend or sister or brother. It's just work.

Creating is often about fantasies and projections and ideas and stereotypes and technical aspects and so many other things that leave the participants feeling clinical and just doing what they have to do to make something work and *appear* real.

It is the land of make-believe, after all.

9. What do I do when people (a spouse or partner) want to talk to me about my process — or what I'm doing on set — and I don't want to do that?

As an artist, it's okay — and sometimes essential — to keep parts of your process to yourself. The mystery of it all — where it comes from, how it gets released, how its expression is different for each human being — is what makes it ephemeral and unique. Sometimes, those things don't need to be talked about. Just do it.

And actually trying to talk about them makes things reductive. Love isn't reductive. Nor is compassion or creativity or hope or desire. This is one of the challenges of discussing acting training and teaching — many people like to reduce things to *one* way of doing things. *This* method. *That* exercise. But it's not like that. It's much bigger than that. Filmmaker Mike Leigh addresses this when he talks about the way he works with actors, "I don't regard it as a technique that can be taught, I don't believe in reducing it. The thing that makes it happen comes from something personal and intuitive. It's not like hanging wallpaper."[45]

So, it's okay for you to tell your spouse that you need to keep your creative space private because you're in the middle of it all, figuring it out, solving problems, living it, and wanting to keep the mystery alive while on set. And also protect it. I think a partner can respect someone wanting to be private about their art. And they'll see the finished product when it's done.

On the other hand, maybe it's also about the art of compromise. Since our partners might feel excluded from our process (and that is part of what comes with dating artists), perhaps there is also a way to invite them into the process that fosters trust and can even build a beautiful, co-creative spirit that may enhance both people's lives and maybe even feed the artist's creative energy in unexpected ways.

Maybe they'll want to help you run lines or create an environment where you're able to just focus on doing your work. Maybe it will open up their creative thinking and inspire them to do something they've always wanted to do. When I think about meditation, anytime anyone I was dating asked about that process, even though it's individual and mysterious in a way, I always invited them to experience it for themselves.

So at one level it's okay to say, "I don't really want to talk about it. Let's talk about your day!"

Or at another level you might say, "Well let me tell you about this. What do you think?" And your partner might have a really great response to something you never thought about. Communicate about your art and process from a space of patience and compassion so that you don't feel like you're being a bad partner in wanting to keep things private but your partner still feels included in the process because you've shared more about what that privacy and process mean to you.

It's beautiful to experience something that meaningful together.

10. How can I maintain my life as an artist while being fulfilled in a relationship that doesn't support my artistry?

Well, first, communicate your truth. You just have to say it. "I don't think you support me or believe in me as an artist." Have at it. Get it out there. See if that's true. Maybe you'll discover that that's not what your partner feels at all — but is more of a projection of your own doubts and self-worth. Or maybe, if your partner isn't an artist, he or she isn't aware of what it means to be one. Perhaps you start sharing that part of your life experience with him/her so that he or she can better understand what it means.

Sometimes people don't communicate because they don't know how. That's a start right there. You say, "I don't know how to say this, so I'm just going to need some help and it might all sound crazy or incomprehensible, but let me start from here." And begin.

On the other hand, in communicating your truth you might discover that your art has taken over other areas of your life that you've neglected. So perhaps it's about regrouping. Putting things on hold so that you can attend to your personal life is one of the most important things you can do for yourself, especially if your personal life is out of control and wreaking havoc on all areas of your life.

By opening your heart to share with — and also to listen to — your partner, you'll open to parts of yourself and the

other person that might surprise both of you. Either way it will enlighten you and bring clarity to the relationship.

The truth is, none of us have time for anything (or anyone) that does not support and encourage our journey — or undermines us. Until we take a stand to have more of what we want our life to become, the universe can only give us what we currently are asking for — and oftentimes we're asking for things (usually unconsciously) that don't support the greater vision of who we know ourselves to be.

Actors often separate our career from relationships because we've all had experiences where the dynamic is totally *cray cray!* and then becomes a complete energy drain; and we hold on to this soul-sucking dysfunction because we think it makes us really "artistic" and creative. It's time to let that '80s paradigm about creativity go.

You are not your best when you are a mess.

Yes, you might be more emotional and unhinged and dangerous. But in the long run, not only will that exact a toll, it's also not sustainable or manageable.

Amy Poehler recently said, "I don't want to be around people anymore who judge or talk about what people do. I want to be around people who dream and support and do things."[46]

Yes!

Ultimately, it's not necessary or productive to force yourself to choose between a relationship and your career. Actors are always like, "I need to focus on my career, I can't do a relationship right now!" Why? It's all connected. In fact, if the relationship is healthy and loving, it will help you in all areas of your life, including your acting career. Rather than being a distraction, it will be a source of support and encouragement, and inspire you to be more brave and focused.

Stay strong. Demand more. Life will meet you at your own level of expectation. So up your expectations to generate a more wonderful life. Make changes to seek out the things that are fun. Turn your current challenges into breakthroughs of possibility.

11. What do I do if a scene I'm working on is triggering long-stored trauma that I haven't yet dealt with in my life?

Acting class is not therapy, and I don't have a degree in psychotherapy. A good class, of course, is naturally therapeutic — or maybe a better word is cathartic — because if you're asked to bring more of yourself to the work (parts you didn't even know existed or even hadn't identified), it's of course going to unlock you.

By using yourself to tell story, you're simultaneously healing yourself and others who are watching the art. That's the power of storytelling. Feeling is healing.

Human beings actually *deal* with real things when we are confronted with them head-on. It's only if we're allowed to put them somewhere on pause and perhaps look at them later, that they take on a life of their own. So we have to become at least a little more *conscious* of when we are trying to remain *unconscious* of what's really going on with us. That doesn't mean we have to have it all figured out — or even know how — but we have to at least stop fooling ourselves.

The next step is easy.

Go see a psychiatrist. Get counseling. Talk to someone. Get this crap out in the open. Tackle it. Examine it. See it for

what it is. Break it down. Forgive it. Let it go. Heal it. Bless it. Sanctify it. Celebrate it. Know that you are bigger than it. You're not defined by it.

Something else to consider is that sometimes acting classes can get so fixated on traumas or painful episodes or trying to recall "events" to use them as sense memory triggers or emotional recalls, that they cause more harm than good. And there are lots and lots of classes that do exercises to stimulate our past in this way.

I don't have to go locating specific feelings for a scene to apply to the moment. We don't have to revisit our most painful break-ups and divorces, abandonments and abuses to achieve great acting. Those episodes are collectively carried within. They're there already. They're influencing many of our moments whether we realize it or not.

My suffering doesn't define me. My possibility does.

So let acting class be used to open you to your stuff. But don't get stuck on your stuff. As we heal through it, we're able to channel all of our life's experiences into powerful expressions of self, rather than constantly re-opening old wounds.

A great acting class is a safe space for you to explore and expand self, yes. But it's for acting. Not for acting *out*.

12. I feel like at the studio, we work so much on how *not* to get triggered in day-to-day life, but then we want to get triggered in scenes and get emotional in our work. I'm struggling with the dichotomy.

Human beings get triggered all the time. We then immediately have a physiological, psychological-emotional response. So we yell or flip the person off or make a rude comment. In general, we lose it. Out loud. One could call this an *unconscious* reaction to events.

At another level, we *feel* what's happening to us in certain situations, but then *don't* express it outwardly. So we have a physiological response — our heart races, we feel flush, our palms sweat, we feel tightness in our chest, or a rush of energetic emotion — but we swallow the feeling or choose *not* to express it because we're scared of it or don't understand it or it's not "appropriate". This sometimes can be a *conscious* reaction, even if we do it on autopilot (i.e., "unconsciously"). Some people feel big, booming feeling and let it out; some people feel the same big, booming feeling but shove it down.

In acting, we're going to get triggered if we're listening. Full stop. No doubt about it. *And that's what we want!*

Marlon Brando said that it took him until he was in his 40s to understand feeling. And that up until that time, he would usually respond to feelings he didn't understand with anger.[47]

All feeling is linked to deeper feeling. What may start as anger is really pain, and underneath that might be rage, and hidden somewhere else might be anguish, and deeper still it might be fear, and on it goes. And it's not stacked in any sort of hierarchal manner one on top of the other. Feelings are pulsing through us all the time simultaneously.

Acting teachers might say to an actor who's working deeply with feeling that they created a "layered" performance. It's not layered! *Feelings aren't layered.* They're just coming out. That means that the actor is expressing the complexity of being human, and feelings are coming out in concurrent and contradictory ways.

Much as we try, a person can't compartmentalize feelings. In acting, once you do that, you're "acting".

Our work at the studio centers on being mindful about how we respond to being triggered. When we become more aware of how we get triggered, we can develop the tools to *choose something else* with what we're feeling rather than react — or overreact — mindlessly. Which often leads to one emotional escalation after another. The snowball effect. This is the root of war and destruction and revenge and retaliation. It's the inherent pathology of being human because we aren't taught how to have our feelings in a conscious way first.

If we work from an awareness-based perspective (which is Buddhism or mindfulness or Presence), we can actually

"observe" our feelings. Instead of blindly reacting, we can take a breath and talk about our wanting to react. We *tell* someone how we feel. We express our point of view. This will still have a feeling component attached to it. But we will move through the feeling rather than the feeling moving through us on its own, out of control. From that space, we're able to deconstruct, diffuse, and dismantle the dramas we create in our heads around an emotional and psychological trigger. This then becomes the work. And it's also a more joyful way to experience life.

Let's say someone says something that upsets you. Instead of reacting first with yelling or throwing things (!), you choose to notice in that moment how reactive you are. You choose to breathe and then examine, "Well, why do I want to throw something at them?" "What is it that they said that's so upsetting to me?" "Why is it upsetting?" "Who's really upset? My ego? Me? What's *me* anyway?" "How does their comment have more to do with them than it does with me?"

Your flight gets delayed; you feel rage and scream at the ticket agent. With reflection, instead of seeing the situation as something (or someone) that did you wrong — or did something *to* you — you see that it's just a neutral event that triggered you personally and you apologize. *We personalize all events.* But nothing really happens *to* us. That's our ego's identification with victimhood and entitlement and control.

The correlation to the practice of acting is as we become more aware of how we feel, we can consciously use our feelings in scenes more powerfully. We have dexterity in using feeling to tell story in innumerable ways because we have a relationship *with* feeling, rather than being blindly slavish to it. That's not control — that's technique. That's being able to stay present with everything going on and using it to wield ourselves gloriously in story.

An acting program based on consciousness helps you cultivate a new, reborn relationship to self, to others, to what you're feeling, and ultimately, to possibility. And actually, that's bigger than acting — that's a call to how we can live our lives more productively.

13. How do I live my own passion when I don't feel I have any?

Sometimes we're not passionate about things in our life because we coast, or procrastinate, or avoid. Committing to something that would require us to share our passion is scary and that's why we often shrink from naming it. I want to sing. I want to act. I want to help Honduran refugees. I want to discover a cure for cancer. People might scoff. Our dreams can be trampled on. We can fail. We can be made fun of. So that's why we often keep our passions to ourselves.

When you see art — a painting, a dance, or great acting — and it's transcendent, you also simultaneously see something (or rather *experience* something) within yourself that is connecting to a force greater than you, bigger than the art form, but contained within it and within yourself. It is ephemeral and yet knowable. That's why you are moved by it in the first place. That's what great art does.

When something lacks spirit, seems pedestrian — you don't connect to it, you aren't elevated, you aren't moved. This is because it's just the artist's ego trying to make it happen. A greater energy or force isn't moving through our being. (I should say spirit is *always* moving through each being — but most people pinch it off, limit its expression, don't channel it, have no idea the power within them wanting to be expressed.)

As you continue on your process, be aware of the changes you might be feeling. Be patient. Ask for your heart to be opened. And then forget about it. Live your life and trust that divine knowledge (or infinite intelligence or fate or dharma or process) is working through you and you're being lead. Because you are, if you listen.

Sometimes we might feel something inside us when discussing a current event that we have strong feelings about. Maybe you hear about a cause and you get a tightening in your gut. Maybe you're fascinated by a news story and can't let it go. Perhaps you listen to music and feel a connection you can't describe. Maybe your heart rate rises around certain situations and conversations.

Oftentimes we ignore these physiological responses because they're not practical and we don't see our way into how they could create any sort of career or job or lifestyle for us. So either we discount these urges or we don't even realize they may be an expression of our passion because we're comparing our actual feeling about personal things to what we think it's "supposed" to look like.

I recently listened to a reporter on NPR discussing geo-political news in Eastern Europe. Total bad-ass. She was not only smart, but also passionate. This wasn't evident in any sort of demonstrable way — she didn't get excited or out-of-breath or shout with enthusiasm. But her absolute immersion in what

she was talking about — her expertise and historical under-standing of the topic — struck me as coming from someone who cares deeply about the subject at hand. If she didn't, she wouldn't be invested in being a leading expert in this topic.

I also remember thinking to myself that her intelligence itself was exciting to me. I didn't care as much about the topic as she did, but listening to her expound on it *made* me interested — in her *and* the conversation. I wanted to meet this woman just to hear more of what she had to say!

Passion is like this. Don't get caught up in its form. Some people are externally exuberant. Some people are more in-troverted and cerebral. Some people are more statistically or research oriented. Some people are screamers and criers and jump up and down. All forms are virtuous as long as they connect you to you. So let your passion be channeled the way it *wants* to be, not the way you think it *should* be.

Your passions will always ebb and flow, and sometimes you have to get lost in order to find yourself. This is a process which occurs over and over again through all the phases of our lives. If you don't allow it, you stop growing, and what lies ahead is a blandness of settling into stagnation and ambiva-lence. Now *that's* scary.

So, don't freak out about it. Instead, follow your passion, wherever it may lead — and enjoy the ride!

14. What do I do when I realize the reasons why I'm acting have changed?

Breathe. Relax. That's a normal part of growing up and maturing as an artist. As you get older, you'll start to ask yourself this question more often.

Why am I doing this? It's an important question to ask. Why do you want to act? Or Create? Or live your life as an artist? And for whom?

Sometimes we lose connection to — or allow the business to contaminate — the original reasons why we wanted to create. And for that reason alone, it's important to revisit the deeper reasons we call ourselves artists.

If it's for the applause — that will fade away.

If it's for the adulation, that will be replaced by someone else being the flavor of the month; younger, hotter, smarter, more "in".

If it's for approval, or acceptance, or worthiness, or love, you won't find it anywhere outside of self — ever. You can't get it from a teacher or lover or friend or parent or casting director or agent. Sure, they can support you. But sustainable, replenishing emotional sustenance comes from self.

You have to start doing it for you. For the reasons why you wanted to do it to begin with.

To create. To express. To have fun. To be human. To actually discover yourself. To connect with another human being.

Those are the real reasons we're doing it and we're not even aware of it. We're not even aware of the deeper forces at play within ourselves that compel us to make art. To tell stories. To feel. To emote. To risk. To share. To live life courageously and vulnerably as an artist.

We're brainwashed into thinking our challenges will be solved — we'll live our "happily-ever-after" — once we book the TV series or are starring opposite a huge celebrity or have the perfect boyfriend or the great house or nice car or perfect C-sized boobs. What we realize is that the outer can never replace the inner. There is no happily-ever-after. There is only "choose happiness now". Regardless of situations. We place happiness in the context of a future event, not realizing that happiness is all around us right now.

That realization right there can sometimes throw you for a loop. Once you discover there is nothing "out there" that determines your happiness, you can sometimes have a "What's it all mean?" moment. There's always going to be an inherent emptiness to living life, because nothing in this life is permanent so you can't fill yourself with the transitory, as much as we try. But what you *can* fill yourself with is your own fullness of being alive and celebrating every moment.

The things in life we're taught we want (or need) may be grat-
ifying. Intoxicating. Exciting and fun. And those things are
deserved. They're wonderful. They can be career-building and
part of our journey.

But real fulfillment is in our discovering not only who we
are, but overcoming all the limitations we've placed on
our humanity — simple restrictions of ourselves for being
human — in the pursuit of this thing called acting.

We must start doing it for ourselves. Celebrate who we are.
In the audition room. In the performance. In getting or *not*
getting a job. In the victories and the struggles.

In our deepest primal and spiritual connection to the reason
we wanted to act in the first place: To reflect back to human-
ity what it really means to be human.

Sometimes, that journey might include taking time off.
Stepping back to see how far we've come. Discovering that
we've grown into a new life purpose that could've only come
from our discovery of who we are as actors. Taking stock in
realizing the skills we've learned by being truthful might serve
us in other areas that also are of interest to us. There's nothing
wrong with suddenly realizing in the pursuit of the arts that
you really would like to take what you've learned and become
a nurse. Or go to a war-torn country and do charitable work.
Or be a stay-at-home mom.

There is no "right" way into (or out of) acting. Everyone's career is different and our approach to it and how it unfolds is uniquely yours. There's no expiration date for being an actor. As long as we are human — which happens from conception to death — there are roles to play. So play them. Passionately, lovingly, gratefully, wildly. And realize, like all other phases of life, your reasons for doing things and the feelings you get from them — *will* change.

15. What do I do when I want to give up?

Remember just how much you've already accomplished in your life.

We forget that. Especially when we face constant rejection and hear endless "No's," we begin believing that the negation means there's something wrong with us or we're untalented or flawed in some way. *We're cursed!* We start believing the illusion that this business is harder than any other, that it's stacked against the actor, and that it's impossible to break through.

But if you look at your life, the tremendous amount of effort you exerted to overcome obstacles to get where you are today speaks of the possibility of your spirit. And it also shows that nothing is a closed system. *Nothing.* To think otherwise is to limit something that is limitless. That is — you.

It's imperative that we don't let people preach limitations to the point that we give up hope. Who says that the people "out there" are the arbiters of what's hot or popular or fashionable or talented? They're not. Decide for yourself. You've been doing it all along without your even knowing it. Now do it more consciously.

You are bigger than the rejection. You're bigger than a door slamming shut. And in the world of possibility, there are

simply more doors to knock on that can magically open for you. You just have to walk up to them, but that can't happen if you give up. So don't.

Maybe another way to get through the slump when we start to doubt everything about our existence is to do some practical exercises:

1) Do a 3-for-30 exercise — write down 3 things you're grateful for every day for 30 days.

2) Volunteer at a food shelter or some other organization where you can be in service in some consistent way.

3) Take a vacation. Just go away. Don't worry about whether or not you get an audition while you're gone. Auditions will come and go. If you're feeling burnt out and unsure, a week away can really put things in perspective. There's a lot of science about how being in a new and unfamiliar environment actually automatically reboots us. We become curious and playful and interested in things because everything's new. When we don't know our way around, or maybe we don't even know the language, or which taxi or bus line to catch, we stimulate new neural grooves because we're using parts of our brains that might be more dormant or less often activated in our routine lives.

4) I'm not saying hop on the next plane to Paris — or maybe I am. Or maybe it's as simple as driving a new route to work. Or listening to a different news or radio program. Or walking, or taking the subway or bus when you normally wouldn't. All of these things are *possible*. And they reprogram our habituated neural brain grooves.

5) Start something else actively that you are as inspired about as acting. It might be working with animals or writing, it could be finally taking that cooking class or getting your yoga license. You are a creative being. Your creativity doesn't flow through you *only* when you act, but instead at all times, in all endeavors.

6) Ask other people what they did when they wanted to give up. You'd be surprised to find how many people felt exactly the same way you do right now.

7) Intern at a casting office. Far from being a depressing affair because you're going to see thousands of actors come in and only a handful get a job — it will instead reinvigorate you as you'll see that *no one* has it all together. *No one* is perfect. And, honestly, that everyone falls into the same averages: on any given day, for any given role, most people are cast-able and no one is really that much better (or worse!) than anyone else. (Unless you're Meryl Streep.)

But the good news is that we already have a Meryl Streep. And as great as she is, we don't need another one. What we need is *you*. So don't give up, or we won't ever get to experience you.

16. Why don't I have more fun?

Because you forget to play.

That's the thing. What happened to that?

Since the beginning of time, that's the real reason to be an actor. The ancient Greeks may have called their little skits "tragedies", but the word is a compound of two Greek words: "goat" and "to sing." So, ummmm . . . they were definitely having fun if they were singing songs about a goat.

When did we lose this art of play?

Isn't that why you signed up for that Acting 101 class in college? (Besides trying to find other gays just like yourself? Or for the straights — trying to hook up with the hot drama chicks.)

Well . . . yes! But you also enrolled because it simply looked fun.

What the hell happened?

When did acting — and auditioning — and the pursuit of a life in the arts become a big, fat, dramatic tragedy?

Well, we're a tad obsessed with *drama*. (Turn on any episode of *The Bachelor* and you'll understand . . . it's a cultural epidemic!) But somewhere along the line, we confused something

that is purely an expression of joy and wild abandon for something that is painful and hard and full of suffering.

Watch kids. They play. They commit. They say, "Yes." They do it their way. They believe in their world 100% without having to do sense memory to get there. That's because it's all there. Even at such a young age. Just like it is for all of us. Always. Regardless of our age.

And there's a lot of science now that supports that children need unstructured, free time to play every week for their own emotional and cognitive development. *No more helicopter parenting!*

Just because we've gotten older or been rejected or become a tad jaded or have shut our hearts to possibility doesn't mean that the authentic child-like spirit of who we are isn't still alive within us. It is.

And the work (called a "play") wants to extract it. It wants to wring it out of us and leave it all dripping on the stage floor or the film set or the TV show. But we get triggered in perceptions ("How do I look?"), and doing things right ("How does this look?"), and having to be good ("How do you think I look?"), and measuring up ("How do I look compared to him?").

Permission to play is what provides possibility for us. (Wow, there's lots of "P's" in that sentence).

Give up the "too cool for school" card and be vulnerable. Give up the cynicism for laughter. Give up the embarrassment for going all in. Give up the jadedness for being open. Give up the textbooks and doing it "right" and being perfect for the messiness of being alive and imperfect and creating your own how-to manual.

When you do, not only will you have fun again (!), but you'll realize that's really the only reason you ever wanted to do it in the first place.

To play.

17. Why is creating so hard?

It's not. Creating is a natural state of who we are as human beings. It's in your DNA to create. We're doing it all the time. You create when you greet someone in the infinite ways there are to do that. You create when you get a Dunkin' Donuts coffee. You create when you open the door. You create when you engage in conversation with another person. Smiling is creative. So is looking someone in the eye. Laughing out loud. Creation doesn't *just* look like designing a building or writing a play or being on a TV series. We need to start expanding our world of creativity and see how creative we are beyond just this thing called acting, or writing, or directing.

The part of creativity that *is* hard is pushing through the resistance that we have when it comes to doing something. And that simply requires a paradigm shift and a reboot.

We get inspired. We have huge breakthroughs or gusts of energy that lead us to wide-open spaces in our heads where we feel *everything* is possible. We fly and feel invincible. We begin to truly *believe* that things can and will work out. We feel competent and confident and strong and able. This might last a day or a week (or an hour!) — and then we crash. *Uh-oh.*

This is when resistance sets in. We distract ourselves. We listen to our negative self-talk. We tell people our creative dreams and once they've expressed their reservations, we begin not

only to doubt that it's a good idea, but also whether or not we can even now execute it.

We procrastinate, put off, or rationalize because creating takes presence. It requires us to focus and to take action. In our very disconnected world, the constant stimulation and distraction created by so many "smart" gadgets actually contributes to our collective cultural ADHD.

So we sit down to write or read a play or make some calls to agents, and before we know it, we've got 7 or 8 gossip websites opened on our computer and are watching cat videos on YouTube and people's postings of their glamorous vacations on Facebook. By the time we recover from our mindlessness (and compare-and-despair-ism), we've distracted ourselves *out* of creating.

This is what makes creating hard. It takes discipline. It takes commitment. It takes stillness to become the channel we all are and allow ourselves to be affected by the creativity that wants to flow through us.

The late, great Robin Williams said this about acting, "There's something that happens . . . it comes through you. Basically when you're really firing and it really works . . . musicians have said it, writers say it . . . you're just channeling. That's when you say Divine Inspiration just passes, you're letting it though you."[48]

Creating, then, isn't hard at all because you're not "doing" it. Consider, instead, that you're the vehicle *through which* it's being expressed. Seriously, what great artist has ever thought that he or she was making something genius? Genius is available to each of us from within each of us. It comes from something greater than the ego's tendency to label creativity as "I did that" or "I made that." Your job is not to try to define it or figure out where it comes from. Your job is to just stay open. And take action when the story or idea or impulse appears.

So how do we get there? Try this:

1) Go to a new place to write or read or draw or listen to music.

2) Commit to a set number of hours or minutes of "unplugged" time. Leave your "dumb" phone at home — you'll be okay without it for an hour. Turn off your TV or computer or PlayStation or whatever gadget distracts you the most.

3) Start a writing group that meets once a week. Or get an accountability partner — not necessarily a collaborator, but just a friend or fellow actor who may also be struggling with this issue —and sit in a room together doing your own thing. Or have a standing weekly or daily phone appointment to say "I wrote xx pages today" or "I wrote in my journal for 10 minutes this morning."

4) Designate time each week to do some of the "business" work that is required in *any* career. I know as artists we sometimes neglect that part or think it doesn't matter, but it does in *all* creative endeavors. So make those phone calls you've been putting off. Email an agent. Get new headshots. Ask someone to help you put together your reel. Do production work. Take a business for actors class.

5) Try a different schedule. Try writing first thing in the morning before you get distracted by emails and going online. Or maybe you work better at night after everything is shut off. If you are constantly in the same routine, try something new. Instead of going to the gym, what about taking a movement for actors class? Or try yoga. You'll meet new people and fresh ideas will come to you just from trying something different. Reward yourself for your victories. So maybe *after* you do your creative work, you *then* go online or do some mindless Facebooking or online shopping.

If you set aside creative time for yourself, don't punish yourself for what does or doesn't happen. Just designate the space for a task and then when you're done with it, be done with it for the day. You'll discover that the ideas have always been there, just waiting for us to let them come through. The more you

start doing, the more you'll see that you're blessed with count-less creative ideas and inspirations. What amazing, beautiful, talented beings we all are. The work, then, is to do the work to let those creative offerings be shared with the world.

The Industry

1. Do I have talent?

In the HBO documentary, *Casting By*, the late casting director, Marion Dougherty, talks about how it didn't really matter to her if actors bombed auditions. Or sucked. Or weren't great all the time. What mattered is that she saw something in them and knew that eventually there would be a role that would come along to match the essence of that particular person.[49]

She should know, as she discovered all kinds of talent from Al Pacino and Jon Voight to Glenn Close and Diane Lane.

All of these varied human beings whose careers she helped start certainly are originals. That's the common denominator. (And also that she always trusted her gut about people.)

And it sort of raises the question . . . What is talent? Does everyone have it? What is "it"?

From a scientific standpoint, yes, we all possess innate inner talent. We all have vast resources of potential and possibility within us waiting to be uncovered and utilized. The process for actors (and for all people, really) is about discovering, cultivating, nurturing, harnessing, and finally expressing that talent. And that takes work.

Technique is simply a vehicle for letting your talent be expressed. Emotionally, instinctually, physically. And talent is simply how *you* do what you do.

Your approach, your style, your intuition, your physiology, your tendencies, your physicality, your hopes and fears, your passion and pain. What you bring to a role is unlike what anyone else brings to it. It doesn't mean it's necessarily better — but it is uniquely yours, because of your own personal life that you're living. And that's all you've got. Ever. This one life.

Talent, then, becomes about unapologetically bringing yourself to the work (and being shown how to do that). And the only way you're going to do that and get there (besides having great casting directors ultimately see that quality) is by giving yourself permission.

Or as Tilda Swinton says, "You're always playing yourself. It's all autobiography, whatever you're doing. It's using [the characters] as a kind of prism through which to throw something real about yourself, or something relaxed at least. Because the last thing you want is to look like you're acting."[50]

It's tough because we live in a world where we're constantly seeking validation through the external: Facebook acknowledgments, Twitter mentions, Instagram likes, casting callbacks, agency acceptance, and then comparing ourselves to what we think everyone else is living. (And succeeding at.)

Michael Fassbender had a watershed moment in his career when he finally decided that he was "good enough."[51]

He certainly is.

And so are you.

You're good enough to get the job and have an agent and be on a show and get paid for your work and have an amazing career. It's okay to have doubts; partly by having them, you'll come to the conclusion that you're probably good enough. Doubts often fuel us and are a necessary part of the creative process. Without them we'd become fanatical, dogmatic, and intolerant of the process of life itself.

At the height of his success during the run of *A Streetcar Named Desire* (and for a long time afterward), Mr. Brando battled ". . . what I had been taught as a child — that I was worthless."[52]

What's the saying? Everyone's fighting a battle you know nothing about. So be kind.

And remember to also have doubts in your doubts. And know that to have them doesn't mean you're not talented.

That's the reason you ask that question. Because you doubt whether or not you are. What if you could have doubts and also be talented *at the same time*? Picasso did. So did Marilyn Monroe. So did Steve Jobs. So did Brando. So does everyone. So will you.

2. How do I get an agent?

That's like asking, "How do I get a girlfriend?"

Be open. Ask people out. Put yourself out there. Realize you deserve one. Show people who you are. Let people in. Stop being so scared. It's all the same stuff.

Do a showcase. Invite some agents to your class. Do a mailing. Get a reel together and send it to someone. Get a referral from someone else in the industry. Go to a mixer and when you meet an agent, get her card. Introduce yourself to people as an actor. And be proud of it! Ask everyone you meet if they know of someone you could reach out to. Call an office. Get in a play. Do a web series. Create your own work. Go to a film festival. Realize you deserve it. Don't give up because people reject you.

Don't be ashamed that you don't have a lot of credits or are just starting out or you aren't famous yet or haven't booked anything.

Everyone starts somewhere and even if you've been doing it forever, each moment is like beginning again.

We're in show business and everyone in it knows how it works. People ask other people for favors. Everyone is trying to connect with talent in some way or another. Everyone needs something from someone.

You have to be willing to take the risk. And you need to have your work in order to back up what you want to sell. It's important to remember that it's called show *business*. So in order for an agent to respond to you, you need to speak to him or her in a language they can understand: how will they make money off you? If you're the CEO of your company — which you are — what excites you about the product? Why is it different than what anyone else has to offer? How is it special and unique? Why would someone want to buy your merchandise? Who are you?

The obvious answer is that there's something unique and different about you that no one else brings. This is true. But it still may be too broad. Maybe it's taking that confidence and then spearheading it into your type. And you must know your type if you want to get work.

A type doesn't define you, but it does categorize you into the kinds of roles you can book to make you (and the agent) money. Everyone at some level is typed. Even Meryl Streep. The nature of the medium (TV or film) doesn't really support people being who they're not.

That's because the medium doesn't see beyond the physical. If they're looking for a hot guy, they're going to hire the hot guy. If they're looking for a hot Asian guy they're going to hire the hot Asian guy. They're not going to hire someone to *look* like a hot Asian. If they're looking for a "character" actress, slightly offbeat-looking, and maybe a plus size, they're going to hire *that* type. They're not going to hire Heidi Klum.

In other words, we all are types in one way or another, seen through the eyes of the business. We're the "best friend" or the "dumb blonde" or the "surfer dude" or the "douche" or the "bitch" or the "terrorist" or the "immigrant".

It's reductive, I know. And boring. And *so* 1980s. Welcome to the business. But also know that you are more than that. A "type" doesn't have to label you. It doesn't have to limit you. You do that to yourself.

The business isn't intended to keep you from booking jobs. Instead, it's trying to show you how you can work. Casting directors want to hire you based on how they perceive you, but you don't like your own self-perception so you prevent yourself from committing, from having fun, from being free and expressed in the audition. All because you possess qualities that somewhere along the line you've been taught are not okay to have. That you are less of a person for having them. That if you show them you'll be punished or made fun of or unlovable. Generally, we've shamed ourselves for who we are and the irony is that in order to break through, you have to be who you are. Which includes where you came from and the parts you've been running away from your entire life.

No one is really perceiving you the way you perceive yourself.

Give yourself a break.

You are castable as you are.

You're able to book jobs as you.

You're talented.

Life's too short to waste any more time squandering the gifts you've been given. Whether those gifts show up as incredibly good looks or an offbeat voice. An imposing physical-ness or awkward nerdiness. A heavy build or a vivacious blonde.

Or as Christopher Walken says, "Is typecasting really a problem?"[53]

You just have to get over the obvious limitations a type may make you believe you are. *Get over it!* It's *not* personal.

You *are* potential. Indestructible human potential. You're bigger than a type.

But isn't it good to know you can play one without even worrying about it?

And that's just one of many ways to get an agent. So get on it!

3. How do I work with my agent during pilot season . . . when it's not really working?

What do you do when you test for multiple roles but don't end up getting any of them? What do you do when you see your friends going out for weekly auditions and you haven't heard from your reps in weeks? What do you do when you get bad feedback on an audition — and therefore no opportunity to screen test — when you thought you hit it out of the park? What do you do after pilot season came — and went — and you didn't get a single audition?

Breathe.

Communicate.

Practice mindfulness and remember these few simple points:

1) It's pilot season. Everyone's stressed. You're one of many clients on someone's roster. They're working hard to get *all* of their clients jobs and it's important to have faith that they know what they're doing and they're invested in helping you get work. If they weren't, they wouldn't be working with you.

2) Pilot season is a few short months. What does or doesn't happen in those months doesn't mean you're doomed to be unemployed the rest of your life, or

that you're a terrible actor. It's a tiny window of your life as an artist. You didn't let only the first 4 years of your life define you as a person, so why would you let a couple months do so now?

3) Perhaps it's still early in pilot season and you haven't gotten any auditions yet. You start doubting whether or not you're with the right person, or if they're doing anything on your behalf . . . or if they even like you. Don't panic. Often, the main roles for new shows are offers being made to famous actors so that's why you're not being seen. Once that part of the casting process winds down and the roles have been filled, the casting offices will start looking at other people for supporting roles and guest star and co-star roles. You'll get called in.

Recently, though, I spoke to an actress who was not only not going out for pilot season, but when she was, her manager would undermine her confidence by giving her arbitrary bad feedback and tell her all the reasons why she wouldn't get a role.

Everyone knows the business can be challenging; if you're doing your best and getting callbacks, things are working and it's just a matter of time.

So when someone you rely on isn't supporting you in that process, you have two options.

1) Say nothing and hope it gets better. (It won't.)

2) Express your truth, create boundaries, communicate your needs, find a way of making things work if they're salvageable. If not, cut your losses and get out.

I know that's a scary thought. "Oh my God, I can't be *agentless* during pilot season." But the irony is, if you're working with someone who's abusive and non-supportive — you already *are*. It's like a bad relationship. It's not going to get better. And by staying in it, you're preventing yourself from being available to something new and ultimately healthier.

It's important to retain our dignity and respect as actors on our journeys. Many times, what is being asked of us and what is being said to us can be demoralizing or hurtful. But you don't have to stand for it just because you want a job. No job is worth that. Nor is any agent or manager who makes you feel like there's something wrong with you just because you haven't booked a job for a few months. Or aren't the "ideal" weight. Or haven't come into your own yet. Or are having periods of self-doubt. Or are still trying to figure yourself out.

You're allowed to be human. Remember that.

The ones who care (and are excellent at their jobs, by the way) understand this, and they're in it with you for the long haul. So seek those people out if you're feeling it's scary to

take the leap. They exist! There are many, many wonderful reps out there who do incredible things for their clients. It's like dating. You just haven't found the right one. Keep searching.

And as a coda, remember your representatives are people, too. They often work incredibly hard without so much as a thanks (unless the actor books a job). They have dreams. Not just for you (and all their clients), but for themselves. They are creative and passionate and committed. Things often don't go their way either. They fight for clients who perhaps can't get seen for any role. They stick with people during the lean times of their careers. They put their asses on the line for people. They become cheerleaders and supporters and therapists and family. And oftentimes, their "family" divorces them to go someplace else, right when the big break occurs. *Ouch.*

It's all about relationship. Treat people the way you want to be treated and the circle of opportunity and success expands. That's how we always want to work and create with people anyway. Not to get something, but to realize we're all in this together. And when we create together, everyone wins.

4. What do I do when the agent who wants to sign me only reps disabled people, but I've never identified as disabled and I don't want to be defined by anything other than my acting?

If you turn on a TV show or even a commercial, you see that certain types are represented. Some more than others. There's the blonde or the Asian tech-geek. There's the chubby best girlfriend or the hot muscle stud. There's the Hispanic gang-banger and there's the Midwestern parent. The business is always going to be in the business of reducing people to "types" and then commercializing those types in ways that are comfortable for the widest range of viewers. It tries its best, albeit rarely, to show humanity in all its varied aspects, but a lot of it is discriminatory, or even at an unconscious level people are unable to acknowledge their own prejudices or internalized fears around segments of society they don't understand.

I understand no one wants to only be submitted for roles in a limited way. The potential of being human and telling stories means we can tell the story as a transgendered woman or a wheelchair-bound artist, a deaf actor or amputee. But potential doesn't always mean reality.

So when someone gets submitted only for amputee roles or bald cancer patients or people under the height of 5 feet, it can be disappointing. So maybe it's about having a conversation

with your agent to see if they will be submitting you for a wider pool of roles. It might inspire them to think outside the box and try to change other people's minds by submitting you for things *beyond* your specific physicality.

But at a deeper level, whether a shift changes in the business or not, I think it's important for the actor to never think in terms of being just a type, even though you need to in order to get work. So it's an interesting dichotomy.

At a deep level of awareness, no one limits us but ourselves. If an agent likes you and she has good clients and her people are working, then why is it uncomfortable to work with her? What's the fear? No one is going to see you as limited or handicapped, except yourself. Or even if they do, so what? Change their minds about how they think about people with disabilities.

Look at Peter Dinklage and what he's done for actors who wouldn't typically be considered for leading roles. He didn't start out at the top. He worked his way up. Or maybe he didn't have anyone repping him at all! Maybe he just found his own way by not seeing himself as limited. Or Matt Fraser, one of the leads on *American Horror Story: Freak Show*, who suffers from phocomelia. I met him once in London and he said to me that he knew for 20 years he would break through by being himself and that eventually he would transcend his "type". And has.

All things are stepping stones. *All* things. So an agent you first sign with may not be who you'll be with forever, but it's a start. Talent will rise. So you just have to get started.

I encourage people to say "Yes" to the opportunities that come our way. Work with them, create possibilities out of them, explore them, and try them. Don't let ego and your own position on how you think it's supposed to look keep you from moving forward. As Maya Rudolph said in her 2015 commencement speech at Tulane University (referencing the principles of improv but also how those rules can change your life), "Say, 'Yes.' Say, 'Yes . . . And,' and create your own destiny."[54]

5. How do I book the job?

Stop auditioning!

What? "Tony, I can't get a job if I don't audition!"

Yes, you can. In fact, you book jobs when you take the whole paradigm of what an audition is and turn it on its head.

The term "auditioning" stacks you against yourself, telling you that you have something to prove.

You don't.

Nothing. Nada. Zilch. Zero. Absolutely Nothing. To. Prove.

You are already whole and complete regardless of what anyone thinks about your work.

Emmy winner Bryan Cranston says, "You're not going [to an audition] to get a job, you're going there to present what you do. You act. And there it is. You walk away. And there's power in that!"[55]

So your job is to simply create, the way *you* want to create.

1) **The audition isn't all about you.** I know actors think that the audition all boils down to them . . . but it doesn't. The actor is one of several moving parts

and what you do — or don't do — in the audition is really not that big a deal. The casting director is not obsessing over the mistakes you *think* you made. They have a casting problem and they're hoping you are the answer. But if you're not, it's not personal.

2) **There will be more auditions.** Our lives are ongoing, but we live a moment as if it's the only opportunity we'll ever have. It's not. You'll have another chance to audition. And find love. And succeed. And catch the missed bus. You'll have another chance to book a job and get an agent and be cast in a film. Don't get so caught up in the minutiae of life when your life is actually a continuum of many, many, many moments.

3) **There's no secret to auditioning.** No magic pill, no "correct" way of doing it. No "audition formula". In fact, the more you try to do it "right" the more you're actually doing it wrong. No one cares about your doing it right. They want you to be *you*. And when you do, they'll be interested.

4) **Tell your true story.** A casting director friend of mine said recently, "If an actor comes in and is willing to tell his or her story and they believe it, then we'll believe it." You have to be brave enough to do this. The great librettist, Oscar Hammerstein, said something similar to his protégé, Stephen Sondheim, once as well: "If you write what *you* feel, it will come out true. If you

write what *I* feel, it will come out false."[56] So tell *your* story through the material, and it will be true.

5) **You can be the most amazing actor and not get the role.** Don't worry about it so much. You're not auditioning for a job, you're auditioning for your career. Wentworth Miller confirms this when he says, "You might look at my CV and see I've had 12 jobs, but I've been to over 450 auditions, so I've heard 'no' a lot more than I've heard 'yes'."[57]

6) **Stop thinking about it as a job. It's not.** Every audition is a learning experience. Let's face it. For many actors, auditions are sometimes the only opportunity you might have all week to act. If you're not in a class, if you're not on set, if you're not rehearsing a play, your "audition" is your two minutes to act. That's what a 4-year college degree and a $100,000 MFA in acting has gotten you — literally two minutes to act! *Eeeeek!* So you better put that college tuition to some good use and stop analyzing what you think they want. *You* are what they want.

7) **Give up control of doing something perfectly and instead be human.** Stop trying to figure out what they want. No one knows what they want until they see it. That's the intangible quality of life itself. It's energetic. It's timing. It's essence. It's creativity. It's alchemy. It's luck.

Why do you book the jobs you have no interest in doing? You know the ones . . . *Friday the 13th Part 77: Torture Porn Reunion. . . Leprechaun 3D . . . Godzilla vs. Battleship: The Final Sinking . . .*? Because you simply don't care. You're not attached to how you look or what the casting director thinks of you or if you're making the "right" choices or nailing the part.

You're not focused on the end results or trying to get the job, because truthfully, *you don't want the job!* Then your agent calls and says you booked it and you're like, "Nooooooo!"

8) **Pray for mistakes.** (Doubly important for people who like to control; see #7.) When mistakes occur and you've been taught to embrace them and not deny them — they will usher in very exciting and dynamic moments that aren't planned, orchestrated, and mapped out. You'll go from acting to *being*.

9) **It's not really rocket science.** Understand the material. Make a choice. Go all in. Commit bravely. Listen. React. Have fun. Play.

10) **It's all listening.** Every actor can say a line perfectly. But how you listen to what is being said to you and how it affects you is different for each person in each moment. Surrender to the listening in a way that draws you into the experience and it will draw us in, too.

A student reminded me that agents rarely call it "auditioning". They call you and say that they have an "appointment" for you. Or that a casting office wants to see you. Or your reps say that you have a meeting or you're going in to read for someone.

So stop "auditioning" and what will happen?

You won't have to anymore because you'll be so busy working.

6. What should I tell myself when I don't book the job?

Well what do you *normally* tell yourself? Be honest. Generally it follows something along the lines of the 5 stages of grief. (Sometimes all within the same minute!)

1) Denial. "Ummm . . . *What*? They definitely don't know what they're doing! They'll figure it out and when no one else does a better job they'll bring me back in."

2) Anger. "WTF!? I hate this business!"

3) Bargaining. "I didn't want that crappy job anyway. Lame. A better job is coming along that I wouldn't be available for if I got that stupid role."

4) Depression. "*Oh gawd!* What am I doing with my life? I can't take it anymore!"

5) Acceptance (aka short-term-memory). "Oh, I got another audition? Cool!"

That's quite the mental rollercoaster ride we take, and it often leaves us feeling queasy and insecure. And the same formula could be applied when we get dumped by our perfect boyfriend or girlfriend, when an agent doesn't return our calls, when we get fired from a job, or when we're just contemplating our existence in the universe.

What if we tried another approach by tapping into the ancient tradition of using a mantra as a grounding device to help us weather the storms of life? Not just in the acting world, but living life period.

The word "mantra" literally means an "instrument of thought". And when you begin to use one, you can learn how to go beyond the mind and get out of the vexing self-dialogues we are often engaged in.

We use a mantra to slow down, get quiet; to create new patterns of thought. As an understanding of process. As awareness. The point is to gain peace of mind. No amount of money or fame or popularity or success can provide that for us. Peace of mind comes *from* the mind.

Instead of beating yourself up when things don't go your way, why don't you try any of these more truthful statements?

"I am ready for success." *(You are.)*

"The universe is orchestrating the details for me. It's safe for me to let go. I don't have to control everything." *(You can't anyway.)*

"I'm in the right place at the right time doing the right thing with the right people. Always." *(Boom!)*

"I am peace. I am light. I am love." *(Indeed.)*

"My life keeps getting easier and easier. And more and more fun." *(F'shizzle!)*

"Everything always works out for the best for me." *(It does.)*

"Let me be me. I accept and love myself exactly as I am." *(If you don't, no one else will.)*

Things work out. Not necessarily how we planned, but ultimately, for our highest good. Even then, the "higher good" might mean something that is hard for us or something we have to overcome or change about ourselves. It may not be something that feels "better", it may actually really *suck* — but it's all interconnected.

Let your mantra be a centering thought when everything else in your life seems to be anything but that. You'll find that you'll become more resilient and adaptable. And maybe even start having a lot more fun. Even when you don't get the job.

A job doesn't define you. You define yourself.

And that's what you should remind yourself of when you don't get the job.

7. Why am I getting good feedback but not booking?

Numbers. Numbers. Numbers.

I know it can suck sometimes, but that's just the true nature of the business. You can be the most outstanding actor and that doesn't mean you're always going to book the job.

It's important to remember this as we pursue a life in the arts. It can't always be about being "on". Currently there are 165,000+ actors in our TV/film union, SAG-AFTRA. [58] There are more than 49,000 in our stage union, Actor's Equity. [59]

I'm not giving you these numbers to make you depressed. Let's do the math. Because mathematics actually de-personalizes something that already isn't personal.

If we only get five auditions a year, let's say, the statistics work against us in booking because there are so many intangibles that must be factored into job bookings: how you look, your age, do you have the right hair color for the role, how tall you are, ethnicity, just to name a few.

Mostly, we don't book because these intangibles are out of our control. This doesn't mean you don't focus on what you can improve on and grow — that is, your work.

You study, you work, you enjoy the process, you let go of attachments, you allow yourself to be as fully present as possible, you make bold choices, you listen, you go in and let it all hang out, and then you let the audition go.

That's the hard part. We tend to use the feedback and the result as a reward or an indictment for — or against — our talent. If I book the job, I matter and I'm talented. If I don't book the job, I suck and . . . *I suck*. Neither is true. Some of the most talented people in the world don't book jobs. Some of the most creative people in the world are unheard of. Until they're not.

If you're doing the work, eventually the numbers will tip in your favor.

And you'll stop taking any of it personally.

Because it's not.

8. How do I not take critical feedback of my work personally?

Let's face it. At times, you're going to hate your teacher. *I. Mean. Hate.* (If they're any good.)

The Dalai Lama says, "The enemy is a great teacher."[60]

Why? Because a teacher is going to tell us things we don't want to hear. Things that want to open us, puncture our egos, show us our blind spots, encourage us to be the Light that we are. Screw that! Sometimes we aren't ready to hear these things. We're too scared. We try to grasp teachings from the literal mind only. We're so full of ego, we don't let the process show us the way.

When a teacher gives feedback, he or she is not negating all the wonderful things that are working in our acting. The teacher is there to show us the areas in our work that are blocked and are preventing us from accessing a more powerful, imaginative, and creative self: our true self.

What if we tried practicing gratitude for the awareness we're receiving in being forced to work truthfully? Yes, sometimes that awareness may trigger painful or uncomfortable feelings, but growth occurs by embracing and working with all the things that rise to the surface. Our struggles and challenges (perhaps counterintuitively) are here to help us. And actually,

they're what make each of us really cool. We're all survivors in one form or another.

That's what becoming more authentic in one's work is all about — moving through blocks that get in the way of the work and the transformative nature of the creative process.

So generally, an actor interprets feedback as negative because it brings up our internalized shame and self-esteem issues that have nothing to do with our work. It triggers our preconditioned negative storytelling because someone from our past (generally an authority figure— like a parent) made us think we were wrong or bad because of our actions. We were either made to feel embarrassed or inadequate or unloved or not safe because of the way these people responded to our behaviour.

Therefore, when we're in a position where we're vulnerable (like in class), it also simultaneously makes us feel more defensive because we're misinterpreting the feedback as someone saying, "It's not okay to put ourselves out there. It's not okay for us to feel or express these things."

But that's not what is being said at all. Get the message. Don't distort it or kill the messenger. Then, we'll see feedback for what it is: a vehicle to work through our stuff and get more honest.

We all have blind spots. A good teacher just helps us see them . . . and that's where the deeper work comes from.

9. If I haven't gotten work in my first year in Los Angeles, should I just move back home?

You have to give it time.

I remember a well-known casting director told me it generally takes about 5 years for an actor who moves to LA from New York (or anywhere) to really hit his/her stride, get work, become known to the casting world, and to really start having a career. He was right. Of course, the timeline is different for everyone, but 5 years isn't really that long in the big scheme of things. It really comes down to getting your face in front of people consistently who've never seen you before. Once they know you and know you do solid work *(and aren't crazy!)*, they will start calling you in for roles and hiring you because during this time, you've proven to them that you can act *(and aren't crazy!)*. But those relationships do take time to establish.

I have a student who went in for a TV show 14 times (!) before he booked a role. Had he given up after the first audition, he'd never have booked the job.

You keep moving forward by showing up in life. Even during the crunchy times. Hitting several walls (also known as stagnation) is a very important — and necessary — part of growth. Allow yourself to go through those periods where there seems to be no movement, no victories, no creativity.

Author Alice Sebold says, "It's very weird to succeed at 39 years old and realize that in the midst of your failure, you were slowly building the life you wanted anyway."[61]

So trust where you are.

When we're stumbling around in the dark or lost in the forest, it's difficult to see a way out and trust that you won't be forever stuck there. But there's a sort of calmness in trusting that eventually there will be a light through the dark and you will find your way out. This too shall pass.

The key is acceptance and not panicking. Breathe. To gently allow what *is* to be what is. All suffering has its root cause in our resisting what *is*. So just know that like a cloud in the sky it will soon clear and bring with it either a new expanse of openness and clarity — or another cloud will roll on by to take its place.

Observe and be okay with those clouds or sun or fog or rain or whatever. *It's just weather!* You got to where you are because of *all* the experiences of your life. Not just the great, fun, glamorous ones. All of our experiences collectively serve a purpose, so allow them to *be* and give way to the next step. They always do anyway.

So unpack your bag. Find some nice friends. Buy a goldfish and plan on staying awhile.

10. Why do I get nervous in front of a casting director?

Because we're constantly in our heads thinking people are judging us. And we perceive someone else as having the power and our tendency is to make ourselves inferior. We think they have the power over us, so we immediately create a paradigm based on perceived *lack*. We do this all over the world. We do this based on how people look or how much money someone has or if they're well-known or are the head of a company.

Actors do this to teachers. Lovers do this to their spouses. Employees do this to their bosses. (And yes, I understand that a boss is signing your paycheck.) But the truth is, take away the titles, the credits, the descriptions, the labels — and we're all the same. *All of us.* And it's often *we* who mis-create the paradigms in our head and then fall into roles to fulfill these power plays.

Actors have power. We're the storytellers. They need us. Stop acquiescing your power to someone you *perceive* as having the ability to make or break your life or your career.

Look at where you are now in your life. Who made all of that happen? You did.

That's not to say that you didn't have tremendous, life-changing help along the way by some amazing, supportive, loving people. My point is, *you* have the power to make something

happen in your life. *You* are the star of your own movie, but you keep casting yourself as the supporting player.

Change the paradigm.

Casting directors like us. (And so do writers and directors and producers.) If they didn't, they wouldn't want to work with actors. But we don't remember this going into the audition room.

Dr. Alan Watkins, who lectures on neuroscience, teaches that emotion is just energy-in-motion created by our biochemical responses that occur due to our physiology. Physiology — which is information sent from our organs to our brain — is then expressed as emotion. Our bodily systems (electrical signals, chemical waves, electromagnetic waves, etc.) send these permutations of energy to our brains, and feelings, then, become our awareness of the energy that is there.[62] For example, if we're in a situation that causes anxiety, the physical symptoms of that state could be a fast-beating heart, sweaty palms, and our gut starting to churn. We might get short of breath and feel nauseous.

I often ask actors, "How are you feeling?" during a scene. And they say, "I don't know." Or "I'm fine." Or they describe it in a vague way that doesn't actually pinpoint what the feeling is.

But we can't change physiology without knowing that we have control over how our physiology makes us react to things. So changing physiology can change our patterns of behavior.

Shift the paradigm of how we describe this energy within us. Instead of negative associations or constantly reaffirming "I'm scared," could they not be positive? Like "I'm feeling excited," and "This is just performance energy," and "What I'm feeling is going to transform into other feelings I need for the scene."

Changing our relationship to what we feel creates openings. Just by acknowledging when we're in a nervous situation helps to diffuse the nervousness. Acknowledging what we're feeling allows us to mindfully take a breath to start allowing ourselves to relax and stop resisting.

So breathe through the heart. *Consciously.*

It is the epicenter of feeling and also oftentimes, it is one of the prime areas we feel the experiences of stress in our bodies. Partly this is because it's an immense power grid (and according to Dr. Watkins, generates more power than any other part of our body), but also by breathing through the heart we begin to move our awareness from our very noisy, turbulent, and sometimes sabotaging heads into our heart center.

And really, isn't that what we're all striving for, always? To be more heart-centered, fully expressed, free, emotionally available, less analytical and self-critical, more joyful and open?

The science is in.

Let your heart be your guide.

11. Do I have to be off book?

There's no hard-and-fast rule about anything. In life or in acting. Do what makes you feel confident and empowered.

Most actors discuss that they feel more free and out of their heads when they have very little time to "prepare" or plan and are forced to just go with their initial instinct on things. That's partly because the critical voice hasn't had time to set in and overtly start controlling and editing what wants to be expressed by you and through you.

In short, you don't *overthink*.

But you can also achieve this freedom even when working on material for which you're "off book". It's called listening and reacting.

For most auditions, everyone (including the casting director) has script in hand. That's because they understand that everything at one level is a work in progress. Scripts change, rewrites occur, new sides are handed out on the spot.

Familiarize yourself with the text as much as possible and work towards getting off book, but don't make it your only focus. As we memorize and drill and drill and drill, we often get in a set way of saying lines. So, find that happy medium where you feel confident enough with the text but are still fully free and available to the unknown or unexpected.

Science has proven that once we memorize something, our brain's dorsal lateral prefrontal cortex (DLPFC) kicks in. (That's the part that is the editor. The censor. The inhibitor.) We don't want that controlling mechanism to take over as it shuts out what we actually *do* want — which is spontaneity, instinct, impulse, intuition, reaction — and instead we end up just hearing our cue, which isn't deep, reactive listening. It's simply *waiting for our cue*.

Eventually, obviously, we will have to be fully off book. (Once we show up on the movie set or TV show or the opening night of the play.) And that, too, will become part of the process.

Recently, Christopher Walken's co-star on NBC's *Live Peter Pan* TV movie said that every time he rehearsed a scene it'd be different.[63] *Duh!* That's because every moment *is* different when we're actively listening and working off what we're being given. But to many, this is still so surprising and electric. Why? Because actors like to do what works the same way every time. They're trained to say the line the way they *think* it should be said. *Every time!* Even after it's become stale, routine, and obvious, actors are often taught that executing a line perfectly is better than experiencing the moment and all the wild variations that live within it. In the real world, nobody cares about perfection. Trust me, *nobody*.

Don't let the memorization turn you into a risk-averse, mapping-it-all-out, controlled, robotic performer.

Start *living* instead. Let things breathe. When you do, you'll book the job, and then you can concern yourself with getting off book!

12. What advice can you give me when I have to play off of nothing?

I get asked this a lot. My answer is *always* the same. (But let's break this down into 2 different categories.)

Casting Director Situations:

1) It's not the casting director's job to be a good actor. If you've committed to the circumstances of the scene and are making strong choices, then all you have to do is *listen* to what is being said to you.

2) Casting directors are trying to get a feel for you, not trying to act opposite you. Stop making it about them and what you want them to do. If you're aware of how "badly" they're reading with you, it shows you just how much you're *not* in the scene. So get committed and immerse yourself in the moment. When you do, they'll see it.

3) Fundamentally, everything that's going on for the actor is usable. *Everything.* So don't let it shut you down, let it open you up. I'm not saying you'll use your anger in a scene where you're supposed to be getting married. But maybe you will. Or maybe you'll channel and transform the energy that wants to come out as anger and instead use it in a way that opens

you to deeper emotions that are needed in the scene to tell story.

On-Set Situations:

You might end up working with co-stars who aren't supportive or don't want to be there for their fellow creators. Or worse, are resentful that you're even there for some crazy reason. (There's a story of a famous actor who had to carry his co-star out of a bombed-out building in a scene. Every time the director would call cut, he'd drop her! How's *that* for support?)

Look, it can totally suck and it's incomprehensible at one level, but instead of worrying about it, try to solve the problem.

1) Always talk to the director first to see if she can engage the performer in a way that is supportive of your needs.

2) If the other actor is difficult to work with, you might want to say something to him. "Hey, is it me? Is there a problem here? *Is there some reason you keep dropping me on my ass?!*" Perhaps he's completely unaware he's behaving in a way that's making you feel unsafe. Communication is the key. Maybe he'll change his tone. Maybe not. If he doesn't, use it.

3) If your co-star refuses to give you lines when it's your close-up, ask the director to stand off-camera and

feed you the lines (or someone else can do it if she can't — whoever it is should just say the lines). Even if they aren't the best readers in the world, your ability to look into someone's eyes is the most important thing. Connecting in that way is going to free the lines up for you as you're saying them.

4) If that is not an option and they're just getting your close-ups or your P.O.V. shots, simply say *their* line to yourself first *before* you respond with your line. This can happen before the director calls "action" or after. If you wait until after she calls "action" and then you take the moment to say the line to yourself before you speak — let your director know what you're going to do. They can edit the scene from any place they want to. In fact it may help them to have a little lead-time before you speak.

5) If for some reason this is not possible — simply remember what happened the moment before this scene started. Don't play anything, just mentally take yourself through the events of the prior moment or scene before (whether you have shot it yet or not). Commit to psychologically living that prior moment and then let the circumstances of this current scene and what you have to say come out of that cellular memory.

6) Still, if things only get worse, your director is probably as aware of the problem as you are. Trust that

he or she is trying to fix it. If no one does, protect yourself and do whatever you feel you need to do to get to where you need to go in the work.

Everyone ultimately has their own process and you have to respect that and hope that people will show up for you in the way that you would show up for them. Sometimes that's not going to happen, so you just have to find whatever works for you.

Stay focused on what you have to do and don't get distracted by other people's insecure and immature behavior. Make sure the situation doesn't rob you of your power.

When I was in my 20s I was doing an Off-Broadway show that was a hit and we got an extension on our run. Everyone was excited. Not me. Why? One of my co-stars was a raging bully. One night, after he made yet another joke at my expense, I pulled together my courage and walked up to him — dramatically getting in his face — saying that if he ever talked smack about me again, he wouldn't be able to. *BAM!* I was shocked. He was shocked. I was scared. He was scared. But he got the message, and for the rest of the run he went from "Mean Girl" to "Little Miss Sunshine".

I'm not advocating violence or the threat of it, but sometimes you have to take matters into your own hands and meet yourself (and others) at a level of self-respect and self-worth that you won't compromise.

It's truly alchemy that makes something work creatively. Sometimes it doesn't in the end, and that's okay as that's part of the collaborative process. Win some, lose some. But sometimes things do work and you feel it and can see it and it takes on a life of its own.

And sometimes, the thing you're thinking absolutely did *not* work in the filming actually does work out in the end. It's hard not to be judgmental of our work and worry that it may not come together. Especially if you feel like you're creating performance all on your own, or aren't being given anything by a fellow actor or a director. But you have to ultimately have faith that you got the job for some reason, and hopefully, these intangible qualities that make you unique will also be visible to us watching the final product.

At the end of the day then, we have no control over how it all comes out, so all we can do is leave nothing in the reserve tank. Go for things fully. Be passionate and committed and present. And then let it all go.

13. How do I get more from my director or teacher or co-star (or lover for that matter)?

If you feel like you need more — ask.

If you don't understand what's being said — get clarification.

If you feel stuck or confused or frustrated — express.

If you want to be pushed more — demand it.

If you face your own resistance — take responsibility for that resistance and move through it.

If your needs aren't ultimately being met — communicate it.

All teachers (and people) operate from suppositions at some level. In other words, if the student, or friend, or lover doesn't express what's going on — or when they might have a problem — the teacher, or director, or producer assumes that nothing is wrong.

When you express what's going on for you, this is what happens:

Breakthrough created. Problem solved. Growth continues. On we go.

14. How do I get the work to feel open and free when I have specific moments to fulfill for the director?

Brando said, ". . . you direct yourself in most films anyway."[64] At one level he's correct because directors often hire actors who they know are self-sustainable, do their work, and make their jobs a lot easier. But it's also important to remember that directors are also there to help evoke a performance.

When you're acting, just act. Your job isn't also to be the director.

Directors *want* actors to be great. Their goal is to get everyone as truthful as possible. That's what a director is trying to capture onstage or on film.

Sometimes it's going to feel technical, and there's not much you can do about it but trust that you have technique working for you and it's doing its job for you even when you feel robotic or in your head or you're on your 40th take of the same scene.

What's being asked of us isn't always easy. To capture these fleeting life moments in the most honest, non-"actory" way possible — all while doing so with a camera in front of our face and a hundred people sitting around watching us. (Or worse, people bored and not paying attention, as they're actually more interested in the snacks at craft services!) These distractions are going to put us in our heads and that right there

will make us feel disconnected from the freedom and ease we often feel when we're just creating wildly.

At some level, you have to trust that you got the job because there's something inside you that the director saw that tells the story in a way that most fulfills her vision. Since you got cast, you can do it. *Remember that. You. Got. Cast.* Part of being an actor is to show up and make choices and go for things. And part of it is also being open to moving in directions you can't see because you're in it. That may mean that the director sees the story being told in ways that you can't.

Also, remember to ask for help if you're not feeling as free as you think you can be. That's what you have a director for. She may be able to help you, she may not. But whatever the case, just expressing what's going on for you can free you into getting out of your head.

One other thing. When you do a take and the director calls "cut" and they're moving on and you don't get any feedback — or maybe you do get feedback and the director says, "That was fine." — don't interpret that as having done something wrong. "*I'm terrible!*" Directors command an army of different people doing different jobs. When she hires actors who do what they do and she doesn't have to do anything to them, it's one less piece of the puzzle to solve. Believe me, if they weren't happy and you weren't doing what they wanted, you would hear about it!

Woody Allen said about Cate Blanchett as they worked together on her Academy Award-winning role in *Blue Jasmine*, "I always feel if you hire great people, the best thing is to get out of their way and let them do the things they have been doing for years."[65]

Or take a tip from Helen Bonham Carter, who finally demanded that her director and longtime partner, Tim Burton, tell her when she did something he liked. Maybe it was the familiarity of working together on so many films or maybe she was feeling that he took her for granted and didn't acknowledge her on set like he did other actors. Whatever the case, she threatened that if he ever wanted to work with her again, "He has to give me a good compliment, which isn't 'Oh, that was good, that was fine.'"[66]

I love that story. She stood up for herself. She communicated what she needed. She found a way to alleviate the stress that comes with going in our heads thinking we're awful when we're actually doing just fine. So, express yourself and you'll probably find that the director will be there to help you express even more bravely.

Everyone's invested in creating the best possible project. We come together to do this weird thing called sharing-a-moment-in-time with a group of strangers to tell universal stories. Time, energy, and money are invested in doing something that will hopefully be meaningful to not only everyone

involved, but ultimately, to all those who watch the finished film or TV show.

The director wants what you want. Together, you can find it.

15. What do I do when the job doesn't really allow me to explore and create and discover things?

All acting jobs aren't going to be all things to you all the time. And that's okay. It has to be, because the fulfillment or freedom or desire to explore isn't going to be possible in all forms of the work. But that doesn't mean you can't learn a myriad things from each experience.

Rose Byrne says, "Do everything, try everything. All work is noble, and each job is a valid experience."[67]

When you let different jobs be different things and accept them and bless them for what they are (you're still getting a paycheck!), you'll be okay working on a show or doing a piece in which you maybe just have to show up and say the lines. You can do that as committedly and as professionally as you can and then you go seek your joy somewhere else. Sometimes it's just about a paycheck and sometimes it's more. But even when it's just a paycheck — can't that still be an offering of gratitude? You're doing what you love. You're paying the bills. You don't have to do a 9-to-5. So there's a lot to celebrate.

And a deeper way of understanding is to perhaps not label jobs as "bad" or beneath you in some way. Find the joy inherent in each creative experience, as there's always something to learn.

So for example, instead of thinking that the job is "dull" or "unexciting" — perhaps you can use it to find the joy in a different aspect of the work. Going to a set miserable or feeling uninspired (or ungrateful) can potentially bring misery and uninteresting work from the actor — and perhaps even get one fired or never asked to come back for more work. If the writing or directing is bad or style of show is limited creatively, look for the fun elsewhere in the project to change the paradigm. Maybe you can find joy in just being on a set, period; or find joy in potentially meeting other inspiring actors and expanding community (you never know what cool projects other actors are creating, right?). Plus, the snacks at craft services are always a bonus!

If you're not being challenged on a gig, make it your mission to explore building the acting muscles that you'll use on other fantastic and dynamic projects; or be curious in seeing what new discoveries about yourself as an actor may come from this unexpected situation. Sometimes we learn as much from bad experiences as we do good ones. Maybe even more. So maybe you learn what *not* to do on set as an actor. If you go into a situation not only expecting boredom or difficulty, you also become co-creator of that boredom, disappointment, and difficulty. So stay open to challenging situations and you never know what amazing projects other people on this frustratingly constricting set will want to bring you in on because you're such a blast to be around.

It's like relationships. One person isn't going to be all things to you all the time. It's unfair to expect that of that person, and it's also not possible. If you let go of the expectation that one person — or each acting job — is going to be the most fulfilling, exciting, dynamic, soul-expanding experience in your life and instead just allow it to be what it is, you'll have a lot more fun. And you'll also discover — if you remain open — that just working for the sake of working might be its own sort of reward and joy.

16. How do I learn to stop judging — and complaining about — the business?

Well the easiest and most practical answer is . . . *drumroll, please* . . . just stop it.

Don't let that thought see itself through. Stop it mid-sentence. Don't let it steal more of your energy in a way that is not conducive to your happiness or forward-moving momentum. Actively participate in your thoughts and don't let them run on auto-spin cycle. When negativity, habituated thoughts, and doom-and-gloom clouds start forming, say out loud, "Stop it." By doing so, you're catching yourself in the moment and preventing yourself from getting into an already well-defined neurological groove.

The challenge is always going to be to not let the "business" side of *anything* rob you of your joy of the creative part.

We can minimize this by trying to approach the business — and all the needs it requires us to fill — from a creative head space.

That's right; learn to get creative about the business. Learn to make that part as fun as the acting part. Actually, when you think about it — it can be fun.

Meeting people is fun. Networking. Getting to know people. Convincing someone that you have something to contribute

and share. Letting people see how passionate and talented you are. Being willing to work hard to get everything in order (headshots and reels and bios and resumes and knowing casting directors and staying in shape and growing as an actor) can be fun.

I think the breakthrough occurs also in understanding that at the end of the day it's *work*. All of it. That doesn't mean work can't be fun. But creating anything that matters — doing things that require time and energy and commitment — is work.

Writing this book is work. So is doing a show on Broadway 8 times a week. Arriving on set at 5am and working 12-hour days. Being prepared and ready to shoot at any moment. Staying focused and being patient and staying in a career that takes a long time to show results *is work*.

Of course you're going to get discouraged, and at times complaining is going to be the only viable option! But let it go. It just doesn't serve us in the long run. Take the energy you use in complaining about things and find a more creative outlet: go write a song, start an improv group, get your reel finished, shoot a web series, write the one-woman show you've always thought about writing, develop your brand, take a casting director to lunch, read some Shakespeare, intern at a production house, develop a short film idea, call up 10 carefully selected agents.

There's always something to do. The more you get active in your life, the less time you'll have to sit around and complain about things not working, because you'll take matters into your own hands and make them work.

There's a saying: "Great minds discuss ideas; average minds discuss events; small minds discuss people."[68] Eleanor Roosevelt said it. And she sounds to me like a great mind.

So be a great person. Because you are.

17. How can I stop seeing myself as a failure?

Stop letting the industry's standard of success define how you see yourself.

Ellen Page said this recently: "It's weird because here I am, an actress, representing — at least in some sense — an industry that places crushing standards on all of us. Not just young people, but everyone. Standards of beauty. Of a good life. Of success. Standards that, I hate to admit, have affected me. You have ideas planted in your head, thoughts you never had before, that tell you how you have to act, how you have to dress, and who you have to be. I have been trying to push back, to be authentic, to follow my heart, but it can be hard."[69]

Don't let society's warped sense of what success looks like make you question that pursuing your dreams, living life to the fullest, dedicating your life to exploring who you are as an artist isn't a "successful" life just because you haven't "made it" yet.

What's "making it" look like anyway? If you use the external definition of success, you're *never* going to make it. There will *never* be enough. If you make money, you'll want more money. If you have a house, you'll want a bigger house. If you are doing small films, you'll want to do bigger films.

What human beings forget is that it's all in the *experience*. Not the end result.

There's nothing wrong with wanting to succeed and stretching into new territory and reaching for new possibilities. That's why we're here. But when we let our happiness — or our definition of success or our own self-worth — be tied to the external manifestation of things, we will always lose that battle.

Tony Hale said that he had a lot of disappointment when he got *Arrested Development*, even though it was a huge break for him. "It didn't satisfy me the way I thought it was going to satisfy." Because of all the expectations he placed on it and how our business is constantly asking, "What's next? What's next? What's coming next?" His friend gave him the best advice ever. "You have to wake yourself up 100 times a day to where you are." It forced him to stay present, which he says, "Is really hard but it's a lesson I'm trying to learn."[70]

The grass isn't greener somewhere else with more stuff and more things. The grass is greener where you water it.

Similarly, in a recent SXSW speech, filmmaker and writer Mark Duplass talks about our obsession with "getting somewhere" and how everything's supposed to change once you've created something that everyone says matters. So we work to get to a new level in our lives and then we think, "This time the cavalry is beating down your door."

But when the cavalry doesn't come, that can be disappointing to any artist because of our relationship with what we think creating leads to.

But, as Mr. Duplass says, "Here's the good news: Who gives a f*** about the cavalry? You are the cavalry. . . . No one can stop you from doing exactly what you want to do. If you can accept that the cavalry won't come, and if you can be the cavalry, it gives you a chance to be happy."[71]

You don't need a corporation to acknowledge you anymore. You can self-create. You can put something up that draws people to you. You can green-light yourself. You don't need validation or support or admiration or, God forbid, *approval* from anyone else to tell you how or what to create.

Are you pursuing your dreams? Are you doing the best you can? Are you listening to and trusting your own inner voice? Are you being honest and exploring more deeply what it means to be human? Are you taking risks? Are you creating? Are you working on things that make you stretch and inspire you? Are you discussing things with friends that fuel your passion and stimulate ideas to create something together? Are you loving people?

That's success.

Or as the famous musical conductor of the Boston Philharmonic Orchestra, Benjamin Zander, defines it, "Success isn't about wealth and fame and power. It's about how many shiny eyes I have around me."[72]

How many hearts you touch. How many people you inspire. How many eyes are shiny because they are filled with feeling (and perhaps tears). Now *that's* success.

18. How do I learn to enjoy the career I'm having?

Part of what being alive and having this physical experience is about is having wonderful desires that show up in the *physical*: a beautiful marriage, a Hollywood premiere, a house in the Hills, a lead on our own TV show.

But we get so consumed with going for these "events" that we forget that most of our lives are made up of all the stuff *in between* them. We end up wasting so much time waiting for what we think is our *real* life when it's already happening at all times.

We have to live the minutiae *in between* the events as if they were the events themselves! Because they really are. If most of our lives are being spent there, how do we start to live our lives more in what we casually brain-drain dismiss as the mundane? The plot points are just as important as the action sequences in a movie, people! (Although it seems that most of us really only get excited about the explosions!)

First, it's not easy. When you're standing in line at the grocery store in the 12-items-or-less lane and the person in front of you has 50 items and you're reading the covers of those glossy magazines talking about other people's exciting life "events" and you think to yourself, "This can't be my life standing here in line, can it?"

It is.

It's not easy when you get the call from your agent that you didn't get the job. *Again.* It's not easy when you come home to find out your boyfriend or girlfriend has moved out.

But essentially *all* of these moments are *event* moments, they just aren't being lived that way. But also, they lead us to other event moments of our lives. Without them there is no future event. If we can learn to appreciate them a little more, a few things happen: We get happier, we stop living for the future, we become less stressed because we let go of control, we let things unfold naturally, we wake up, we stop taking things so seriously. We stop the pointless exercise of compare-and-despair-ism which robs us of our accomplishments *and* our joy.

We realize that the single greatest cause of our suffering is the belief that the things we don't have in our lives are things we must have in order to be happy.

Student Shailene Woodley taught me a lesson about this at a *Divergent* screening the night before the film's premiere. I said to her, "Oh my gosh Shai, I'm so happy for you!" And then I screamed, "It's all going to be so exciting for you!"

She looked me squarely in the eyes and laughed, "Tony, it already *is* exciting." Touché!

19. What's the best advice you can give an actor?

I've been known to say from time-to-time that, "Things always work out."

But "working out" doesn't mean without challenges. Or getting everything you always wanted. Or that life won't hand you a number of obstacles you have to overcome.

And that's a metaphor for the business as well. Your career is never going to look like you thought it would. Ever. Your way into acting and the path it takes you on and all you can learn from it is going to be much more expansive — if you let it be — than you could've ever imagined when starting out.

I think the tricky thing about things working out in "the business" is that it requires you to say a hearty "Yes!" to a life in the arts while at the same time giving up all expectations moment-to-moment of what you feel it "should" be.

So having faith that things will work out when you follow your bliss isn't Pollyanna-ish-talk. It's truth. But it also requires sensitivity to how other possibilities and insights can come out of our initial desire (to act) when we begin our creative journeys.

So being open — and making a commitment — to a career as an actor can show you so much about your life.

It's not a call into acting. It's a call into life. And a call to be more human.

It's not a profession. It's a way of being.

It's not about a job. It's about expressing oneself.

It's not about character. It's about you.

It's not about having it all together and being perfect and not failing. It's about sharing your fallibility and vulnerability and courage and fears.

When you do, you give other people the permission to do the same.

That's why acting is important.

Art. Beauty. Revelation. Spirit. Creativity. Enlightenment. Redemption. Forgiveness. Inspiration. Compassion. Love.

It's all in there. Acting gives you that. And that alone ensures that it will all work out.

Epilogue

What's the #1 thing I need more of in my life and work?

Love.

What else is there?

Why are we here? Why do we feel compelled to tell stories and reflect back to humanity what it means to be human? Why do we sit in dark theaters with strangers and watch performances that are specific and individual, yet universal at the same time?

Well, if it's not love, then what is it?

It's not only *the* driving force behind our expression as artists, but ultimately it's also a powerful, expanding energy that can renew, re-inspire, and regenerate our enthusiasm for life and for creating.

And love comes in so many forms: Eros, Agape, brotherly, friendship, familial.

We look for it generally in one way — the kind that's romanticized in movies and *Fifty Shades of Grey* novels — when we

don't realize that real, authentic connection is what we're after. That's love — connection with others, connection with self, connection with the moment and all it has to offer, connection with the words we get to say as actors and the stories we are blessed to tell. While we have the time to tell them.

That's love.

Filmmaker John Cassavetes said, "To have a philosophy is to know how to love and to know where to put it."[73]

A philosophy in creating and how to create, then, is love.

Similarly, Ingmar Bergman (who directed over 60 films) apparently was quoted as saying, "Films aren't important but people are."

Meaning, when we come together with people who inspire us and encourage us to become all we can be, that's love. Creating with fellow artists to tell stories we must tell. That's love. Going beyond our limitations and fears of what we thought was possible. That's love. And that's the real reason why we're doing it.

Sure, success is great — booking jobs, making money, fame. But what if we started to let acting be an expression of our saying to ourselves and to the world, "How can I love?" "Where can I love?" "Whom can I love?"

To be optimally expressed — to be *free* — requires us to shift the paradigms we hold around love. And mostly, the limitations we place around it.

Often we hold onto it, saving it for that "special someone", scared that if we give it away too soon we won't have anything left when that perfect time (or person) arrives. The perfect time is always now. And the perfect person is always who's right in front of you at this very moment. Love is the greatest renewable resource on the planet. (In fact, it's the resource that sustains, regenerates, and heals the planet.) It will fill you right back up once you start giving it away. To all people.

So why do we hold onto it? Start sharing it. Everywhere.

In an audition room? Learn how to love the opportunity you've been given and the chance to show people how much you love to create by doing so. That shift alone will change your work from fear — "Am I doing this right?" — to "This is how *I* choose to do it." That's love.

In your creative work? Be brave to go to the places that counterintuitively seem to evoke feelings contrary to love. Only by expressing them do we learn how to stop judging ourselves and accept and love all parts. That's love.

In your day-to-day life? Start putting down the phone and looking people in the eye. Smile. Share a moment — no

matter how brief. When you begin to realize that acting is ultimately about the exploration — and therefore the acceptance — of self, you'll fall in love with acting (and perhaps yourself and other people) all over again. That's love.

What can be more exciting than telling someone, "Yeah, I'm off to self-study class."

"You mean scene-study?"

"Nope. *Self*-study." And what can be greater than that?

That's love.

Bibliography

1 Stark, John. "Alone in the September of Her Years, Elaine Stritch Beats Booze to Score a Comeback in a Woody Allen Drama." *People*. Vol 29, No. 1. January 11, 1988. Magazine. Retrieved from: http://www.people.com/people/archive/article/0,,20098055,00.html

2 "Marion Cotillard." *The Internet Movie Database*. IMDb. com, Inc, 1990–2015. http://www.imdb.com/name/nm0182839/bio?ref_=nm_ov_bio_sm#quotes

3 *Boyhood*. Dir. Richard Linklater. IFC Productions. 2014. Film.

4 "Objective." Noun Def. 1. *Oxford Dictionaries*. Oxford University Press. Web. 2015. http://www.oxforddictionaries.com/us/definition/american_english/objective

5 Moore, Sonia. "The Stanislavski System." New York, NY: Penguin. 1984. Print.

6 Gladwell, Malcolm. "The Tipping Point: How Little Things Can Make a Big Difference." New York, NY: Little, Brown and Company. 2000. Print.

7 *Star Wars: Episode V — The Empire Strikes Back*. Dir. Irvin Kershner. Lucasfilm Limited Production. 1980. Film.

8 Cohen, Leonard. "Anthem." *The Future*. Columbia Records. 1992.

9 "Peter O'Toole and a Young 'Venus'." Melissa Block. *All Things Considered*. NPR. National Public Radio. Web. January

16, 2007. http://www.npr.org/2007/01/16/6869925/
peter-otoole-and-a-young-venus

[10] Brando, Marlon. *Brando: Songs My Mother Taught Me*. New York, NY: Random House. 1994. Print.

[11] "Philip Seymour Hoffman's 'Capote' Obsession." Madeline Brand. *Day to Day*. NPR. National Public Radio. Web. September 26, 2005. http://www.npr.org/templates/story/story.php?storyId=4864379

[12] "Inside the Actors Studio." Season 18, Ep 12. *Bravo*. Web. February 10, 2012. http://www.bravotv.com/inside-the-actors-studio/videos

[13] Chödrön, Pema. *When Things Fall Apart: Heartfelt Advice for Difficult Times*. Boston, MA: Shambhala Publications, Inc. 1997. Print.

[14] Lopez, John. "Jesse Eisenberg: 'Every Time We Get a Nomination, It Makes Me Realize How Much I Was Losing Before'." *Vanity Fair*. January 19, 2011. Print.

[15] Moring, Mark. "How Do You Play 'Righteous'?" *Christianity Today*. Web. November 21, 2006. http://www.christianitytoday.com/ct/2006/novemberwebonly/oscarisaac.html

[16] Riley, Jenelle. "Tilda Swinton on Why She Doesn't Consider Herself an Actor." *Variety*. Web. April 15, 2014. http://variety.com/2014/film/features/tilda-swinton-on-why-she-doesnt-consider-herself-an-actress-1201157011/

[17] Silver, Tosha. *Outrageous Openness: Letting the Divine Take the Lead*. New York, NY: Atria Books. 2014. Print.

[18] "Science of Mindlessness and Mindfulness." *On Being with Krista Tippett*. American Public Media. Web. May 29, 2014.

http://www.onbeing.org/program/ellen-langer-science-of-mindlessness-and-mindfulness/6332

[19] "'Shadow' Carried by All, Says Jung." *New York Times.* October 22, 1937. Newspaper. Retrieved from: https://www.nytimes.com/books/97/09/21/reviews/jung-lecture2.html

[20] *NOW: In the Wings on a World Stage.* Dir. Jeremy Whelehan. Treetops Productions. 2014. Film.

[21] Gardner, Jessica. "Film/TV Actors to Watch." *Backstage.* October 19, 2011. Web. http://www.backstage.com/news/filmtv-actors-to-watch/

[22] Strasberg, Lee. *At the Actor's Studio.* New York, NY: Theatre Communications Group. 1965. Print.

[23] Graham, Daniel W., "Heraclitus," *The Stanford Encyclopedia of Philosophy* (Fall 2015 Edition). Edward N. Zalta (ed.). Web. http://plato.stanford.edu/archives/fall2015/entries/heraclitus/

[24] Mamet, David. *True and False: Heresy and Common Sense for the Actor.* New York, NY: Pantheon Books. 1997. Print.

[25] Andrews, Robert. *The New Penguin Dictionary of Modern Quotations.* New York, NY: Penguin Books. 2003. Print.

[26] Olpin, Michael and Margie Hesson. *Stress Management for Life: A Research-Based, Experiential Approach.* Belmont, CA: Wadsworth. 2013. Print.

[27] Lipton, James. *Inside Inside.* New York, NY: Penguin Group. 2007. Print.

[28] Radish, Christina. "Shailene Woodley Interview THE DESCENDANTS." *Collider*. November, 18, 2011. Web. http://collider.com/shailene-woodley-interview-the-descendants/

[29] Isay, Dave. "Everyone Around You Has a Story the World Needs to Hear." *TED*. March 2015. Lecture. Retrieved from: https://www.ted.com/talks/dave_isay_everyone_around_you_has_a_story_the_world_needs_to_hear?language=en

[30] Williams, Lauren. "Meryl Streep: Why I Almost Turned Down Oscar-Nominated Role in *August: Osage County*." *Metro*. January, 22, 2014. Web. http://metro.co.uk/2014/01/22/meryl-streep-why-i-almost-turned-down-oscar-nominated-role-in-august-osage-county-4271992/

[31] "Scarlett Johansson." *The Internet Movie Database*. IMDb.com, Inc. 1990-2015. http://m.imdb.com/name/nm0424060/quotes

[32] Couric, Katie. "Pacino: Kevorkian Role Unlike Any He Ever Played." *CBS News*. April 16, 2010. Interview. Retrieved from: http://www.cbsnews.com/news/pacino-kevorkian-role-unlike-any-he-ever-played-16-04-2010/

[32] "Sharon Stone." *The Internet Movie Database*. IMDb.com, Inc. 1990-2015. http://m.imdb.com/name/nm0000232/quotes

[34] Gladwell, Malcolm. *10,000+ Hours*. New York, NY: Little, Brown and Company. 2008. Print.

[35] Finn, Natalie. "Lupita Nyong'o: There's "Nothing Comfortable About Being an Actor," But She's Taking Grace-Under-Pressure Cues from Emma Thompson."

E! Online. March 31, 2015. Web. http://www.eonline. com/news/641685/lupita-nyong-o-there-s-nothing-comfortable-about-being-an-actor-but-she-s-taking-grace-under-pressure-cues-from-emma-thompson

[36] Williams, Tennessee. *Camino Real.* New York, NY: New Directions Books. 1953. Print.

[37] Itzkoff, Dave. "With Bill Murray, Just Take the Trip." *The New York Times.* December 2, 2012. AR1. Newspaper.

[38] Swik, Greg. "Juliette Binoche on Making Quentin Tarantino Cry and Why Kristen Stewart is a 'Great Actress'." *Indiewire.* April 6, 2015. Web. http://www.indiewire.com/ article/juliette-binoche-on-making-quentin-tarantino-cry-and-why-kristen-stewart-is-a-great-actress-20141021

[39] "Marlon Brando." *The Internet Movie Database.* IMDb. com, Inc. 1990-2015. http://m.imdb.com/name/ nm0000008/quotes

[40] Partnoy, Frank. *Wait: The Art and Science of Delay.* New York, NY: Perseus Books Group. 2012. Print.

[41] Perls, Frederick S., Ralph Hefferlin, and Paul Goodman. *Gestalt Therapy: Excitement and Growth in the Human Personality.* Gouldsboro, ME: Gestalt Journal Press. 1951. Print.

[42] Travers, Ben. "Watch: Jill Soloway's 7 Tips for First-Time Directors from Her Rousing Film Independent Forum Keynote." *Indiewire.* October 25, 2014. Web. http://www. indiewire.com/article/jill-soloways-7-tips-for-first-time-directors-from-her-rousing-film-independent-forum-key-note-20141025

[43] Fields, Rick, et al. *Chop Wood, Carry Water: A Guide to Finding Spiritual Fulfillment in Everyday Life*. New York, NY: Penguin Putnam. 1984. Print.

[44] Powers, Melinda. *Athenian Tragedy in Performance: A Guide to Contemporary Studies and Historical Debates*. Iowa City, IO: University of Iowa Press. 2014. Print.

[45] Turan, Kenneth. "Keeping an Eye Out for Real People." *The Los Angeles Times*, Kenneth Turan, May 18, 2002. Web. http://articles.latimes.com/2002/may/18/entertainment/et-turan18

[46] Poehler, Amy. *Yes Please*. New York, NY: HarperCollins. October 28, 2014. Print.

[47] "Marlon Brando." *The Internet Movie Database*. IMDb.com, Inc. 1990-2015. http://m.imdb.com/name/nm0000008/quotes

[48] "Oprah Pays Tribute to Robin Williams." *Oprah's Where Are They Now?* August 11, 2014. Web. http://www.oprah.com/own-where-are-they-now/A-Tribute-to-Robin-Williams-Video

[49] *Casting By*. Dir. Tom Donahue. HBO Documentary Films. 2012. Film.

[50] Wood, Gaby. "Tilda Opens Up." *The Guardian*. October 8, 2005. Web. http://www.theguardian.com/film/2005/oct/09/features.magazine

[51] Smith, Brian Bowen. "Michael Fassbender on Shooting Nude, Being Poor, Whom His Oscar Date Would Be." *The Hollywood Reporter*. January 18, 2012. Magazine. Retrieved from: http://www.hollywoodreporter.com/

news/michael-fassbender-shirtless-full-frontal-nudity-shame-x-men-george-clooney-282871

[52] Brando, Marlon. *Brando: Songs My Mother Taught Me.* New York, NY: Random House. 1994. Print.

[53] "Christopher Walken." *The Internet Movie Database.* IMDb.com, Inc. 1990-2015. http://m.imdb.com/name/nm0000686/quotes

[54] Rudolph, Maya. "Commencement Speech." Tulane University. New Orleans, LA. May 16, 2015. Speech. Retrieved from: https://www.youtube.com/watch?v=GPzL42x0LAg

[55] Cranston, Bryan. "Advice to Aspiring Actors." Academy New Member Reception. 2012. Video. https://www.youtube.com/watch?v=v1WiCGq-PcY

[56] *Six by Sondheim.* Dir. James Lapine. Sabella Entertainment. 2013. Film.

[57] World Entertainment News Network. "Wentworth Miller: I'm No Overnight Success." *World Entertainment News Network.* January 6, 2004. Web. http://www.contactmusic.com/wentworth-miller/news/wentworth-miller.-i.m-no-overnight-success

[58] "Union Information." SAG-AFTRA. 2015. Web. http://www.sagaftra.org/union-information

[59] Peter Royston, et al. "Equity at a Glance." Actors' Equity. Web. https://www.actorsequity.org/docs/about/equity_glance.pdf

[60] Dalai Lama. *The Art of Happiness: A Handbook for Living.* London, England: Penguin Books. 2009. Print.

[61] Keillor, Garrison. "Green Canoe." *The Writer's Almanac with Garrison Keillor.* September 6, 2013. Retrieved

from: http://writersalmanac.publicradio.org/index. php?date=2013/09/06

[62] Watkins, Alan. *Coherence: The Secret Science of Brilliant Leadership*. London, England: Kogan Page. 2013. Print.

[63] *Peter Pan Live! Pre-Show*. NBC. 2014. Television.

[64] Playboy and Marlon Brando. *Marlon Brando: The Playboy Interview*. Playboy. 2012. Print.

[65] Harper's Bazaar Staff. "In Conversation: Cate Blanchett Meets Woody Allen." *Harper's Bazaar*. November 1, 2013. Web. http://www.harpersbazaar.co.uk/fashion/fashion-news/ cate-blanchett-woody-allen-december-2013-issue

[66] Belloni, Matthew and Stephen Galloway. "The Actress Roundtable." *Backstage*. December 29, 2010. Web. http://www.backstage.com/news/the-actress-roundtable/

[67] "Rose Byrne." *The Internet Movie Database*. IMDb.com, Inc. 1990–2015. http://m.imdb.com/name/nm0126284/ quotes

[68] "Eleanor Roosevelt." *Wikiquote*. Wikimedia Foundation. May 10, 2015. https://en.wikiquote.org/wiki/ Eleanor_Roosevelt

[69] Abramovitch, Seth. "Ellen Page Comes Out As Gay: 'I Am Tired of Lying by Omission'." *The Hollywood Reporter*. February 14, 2014. Web. http://www.hollywoodreporter. com/news/ellen-page-comes-as-gay-680563

[70] Whipp, Glenn. "Tony Hale talks 'Veep,' Emmys, and his love for a good cruise buffet." *LA Times*. July 31 2014. Web. http://www.latimes.com/entertainment/envelope/ tv/la-et-st-tony-hale-veep-live-chat-20140731-story.html

[71] Kohn, Eric. "SXSW: Mark Duplass's 8 Improvised Tips for Success in the Film Industry." *Indiewire*. March 15, 2015. Web. http://www.indiewire.com/article/sxsw-mark-duplass-8-improvised-tips-for-success-in-the-film-industry-20150315

[72] Zander, Benjamin. "The Transformative Power of Classical Music." *TED*. February 2008. Lecture. Retrieved from: http://www.ted.com/talks/benjamin_zander_on_music_and_passion?language=en

[73] Charity, Tom. *John Cassavetes: Lifeworks*. London, England: Omnibus Press. 2001. Print.

48385835R00134

Made in the USA
San Bernardino, CA
24 April 2017